Layout The design of the printed page

Layout

The design of the
printed page

Allen Hurlburt

Watson-Guptill
Publications

Copyright © 1977 by Allen Hurlburt

First published 1977 in the United States and Canada by Watson-Guptill Publications,
a division of Billboard Publications, Inc.,
1515 Broadway, New York, N.Y. 10036

Library of Congress Cataloging in Publication Data
Hurlburt, Allen, 1910-
 Layout: the design of the printed page.
 Bibliography: p.
 Includes index.
 1. Printing, Practical—Layout. 2. Graphic arts.
3. Design. I. Title.
Z246.H83 686.2′25 77-701
ISBN 0-8230-2655-8

Manufactured in U.S.A.

First Printing, 1977
5 6 7 8 9/86 85 84 83 82 81

Foreword

Few designers of graphic material understand the roots of their discipline or the nature of those elements that underlie the success of a graphic design. The subjective character of the art, coupled with its scattered points of origin and its constantly changing nature, have made its history difficult to document. This is not surprising when you realize that the entire history of modern visual communication can be spanned by living memory.

Most contemporary designers have acquired their knowledge of the profession more by osmosis than through formal schooling. My own education combined a bit of Gestalt psychology with charcoal drawing and rendering in the Beaux-Arts manner, and I was preparing layouts long before I had become aware of the dynamics of de Stijl and the Bauhaus. This book will endeavor to bring together into a coherent whole the myriad bits of information that I have acquired, more or less at random, over my own professional career. Though I have supported my information by extensive research, the results may be less objective than a pure study of art and design history might have produced. In spite of this, or perhaps because of it, I hope this book will be better suited to the needs of a practicing designer or design student than a less subjective study might be. Our view of page layout will begin with an analysis of the forces that have contributed to contemporary style; will then examine those elements of form that create design within a two-dimensional space; will weigh the all-important word and image content that gives meaning to our creative concepts; and will conclude with a brief look at perception and response—the measurement of our success or failure.

In this book, the printed page will be stretched to include posters and covers as well as pages bound inside. The elements of page design will be equally appropriate to all forms of printed matter, regardless of dimension, purpose, or budget. At the same time, we should not let the sheer dynamics of modern graphic design obscure the fact that behind our art lies the great tradition of bookmaking, the tradition that for many centuries has conveyed and preserved the ideas of mankind. This alone should remind us that if contemporary graphic design still has one significant shortcoming, it lies in the need for a greater sense of social responsibility.

A.H.

Contents

Introduction

Layout is not a popular or fashionable description of the design process. Most contemporary graphic designers prefer to be known as art directors, design directors, or visual communicators rather than layout men. Even though these titles may be more appropriate descriptions of our expanding responsibilities, there is no better word than layout to define the unique synthesis of ideas and form that make up

the printed page. Layout is a process that most designers take for granted, or they consider it to be the result of such an intuitive action that it defies analysis, but current evidence indicates that it is a process that needs better understanding among its practitioners.

In the exploration of this complex subject, I will reach back into what some might consider ancient history—however, my mission will not be the making of monuments, but the uncovering of those principles of design that continue to form the foundation for new and innovative design solutions. At the same time, it would be folly not to allow for the nondogmatic character of these principles. After all, the graphic

designer does not share the positive risks that are faced by his fellow designers in architecture and industrial design. No one has ever been hurt by the fractured equilibrium of a page layout, nor has any one been electrocuted by an improperly selected typeface. While we are spared these frightening measures of our failures, we do share a responsibility that is every bit as relevant, and we also share with these designers the same esthetic criteria in the division of space.

It is not surprising that the development of modern graphic design derived many of its ideas and principles from the discipline of architecture. Frank Lloyd

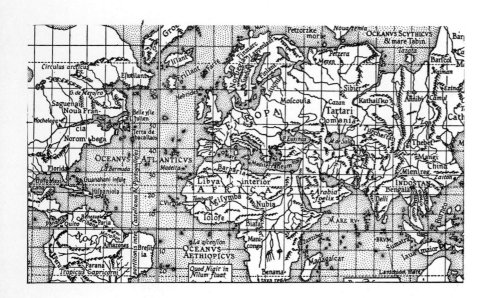

The view of the world revealed in the Mercator projection (above) was still locked in the dimensionless, flat plane of limited medieval science and craft design. The map at right is Buckminster Fuller's Dymaxion concept of ''spaceship earth.'' This dynamic vision suggests a twentieth century creative approach to two-dimensional space.

Wright, Le Corbusier, Walter Gropius, and Mies van der Rohe all made major contributions to twentieth century form and, in the process, influenced the shape of graphic design. Any survey of contemporary design reveals an inescapable interplay among all of the design disciplines—architectural, industrial, interior, and graphic design—as well as the plastic arts of painting and sculpture. Each movement in modern design has demonstrated a parallel growth of ideas in all of these areas.

There is probably no better single demonstration of the difference between traditional two-dimensional design and modern graphics than the contrast between the Mercator map of the world and the dynamic projection of the globe developed by one of the twentieth century's true originals, Buckminster Fuller—engineer, architect, creative thinker, and inventor of the geodesic dome. The world that Mercator mapped in the sixteenth century reveals a dimensionless vision rooted in the handicraft approach of medieval scribes. Buckminster Fuller's version, developed in the mid-twentieth century, is a synthesis of machine-age design that combines contemporary technology with new concepts of perception.

It is not a purpose of this volume to encourage either conformity or imitation, but the design process, like most aspects of contemporary life, does not take place in a vacuum. Today's graphic designer cannot ignore the forces both within and without his field that have influenced the form and function of page layouts. He will also gain from understanding those principles that have contributed—and continue to contribute—to successful design solutions.

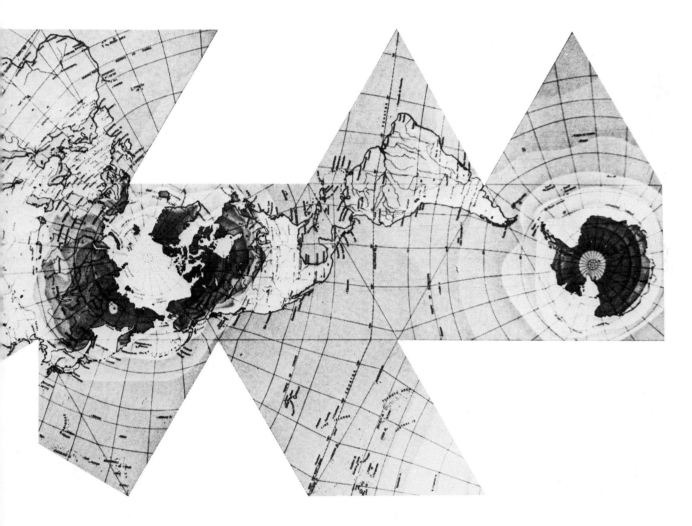

style

Roots of design

Twentieth century style, the design we call modern, is a complex cross-fertilization of influences and art movements, and its development was not a simple step-by-step progression of ideas and directions. Many of the thoughts and principles underlying the modern movement had been forecast in nineteenth century England by John Ruskin, a vastly influential art critic whose writings related esthetic value to morality, and by William Morris, a designer, poet, and social theorist, who promoted the classic revival of typefaces in printing and traditional craftsmanship in the design of products. By the end of the century, American architects Louis Sullivan and Frank Lloyd Wright were beginning to emphasize form and function in their buildings. Typography was beginning to show the effects of the classic revival first advanced by Morris, and feel the influence of the Art Nouveau movement that ended the romantic era in Europe before the modern movement began.

In the opening decade of the twentieth century, several momentous events occurred which were destined to alter irrevocably the course of design. Perhaps the most generally accepted source of modern graphic form was the Cubist epoch launched by Pablo Picasso and Georges Braque in Paris. Behind this school of painting lay the geometry of Cézanne's landscapes and the bold, neo-primitive experiments of Henri Matisse and the Fauves. The 1907 painting that started the revolution was Picasso's *Les Demoiselles d'Avignon*, which, while not yet a truly Cubist work, revealed a greater kinship with Egyptian and primitive African art than with traditional Western art. In this painting, Picasso flattened the surface of the canvas, minimizing the illusion of the third dimension, and substituted

13

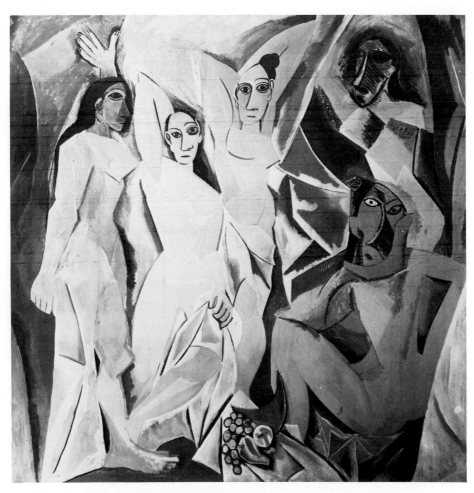

Les Demoiselles d'Avignon, *painted by Picasso in 1907, was the painting that opened the door to Cubism and became a foundation of modern art. Museum of Modern Art, New York.*

aggressive contours and angles for pictorial representation.

Another event of importance in this decade occurred in 1909, when Frank Lloyd Wright completed the now-famous Robie House in Illinois. This landmark work of architecture marked the culmination of the first phase of his career. His use of cantilevered planes to create unbroken lines, poised in a near-perfect asymmetrical plan, provided a critical key to the development of modern approaches to form.

In 1909, the same year that Wright completed the Robie house and the year in which Cubism received its name,

Sigmund Freud published his monumental volume *The Interpretation of Dreams*, a book that was to revolutionize man's attitude toward himself and his sensuality. Quite aside from its effect on medicine and science, this volume was destined to have a profound influence on literature and the arts through its revelation of the unconscious processes of the mind. There was one other event of major importance that took place in this incredible decade. In 1905, Albert Einstein enunciated his theory of relativity that was to change our vision of reality and open the door to scientific and abstract influences on graphic design.

Though it was not clearly discernible then, by 1910 the foundation of modern design was in place. To even the casual observer of art and design history it is apparent that the movements that followed would all, in one way or another, owe a sizable debt to these four events.

The following pages will trace the progress of the developing style in modern design and will attempt to relate that style to the layout of the printed page. In this century, more than any other, the multiple disciplines of design are woven together to form a common fabric of modern style.

The Cubist movement was concerned

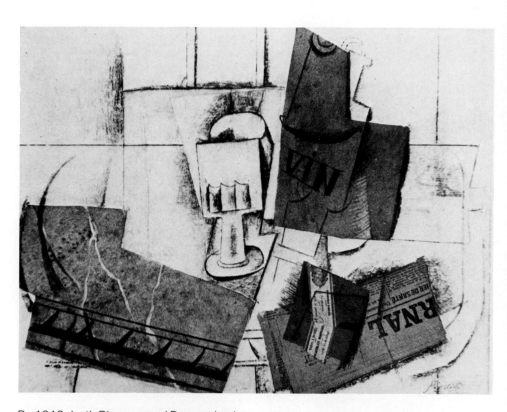

By 1912, both Picasso and Braque had abandoned conventional reality in their Cubist paintings, but they added some real touches to their canvases by pasting on printed objects, as in Picasso's 1914 Still Life with Newspapers. *Dalsace Collection, Paris.*

only with painting and sculpture, but beginning with the Dadaists and the Futurists, the styles and influences began to spread from the fine arts into the other design disciplines. By the time the designers of de Stijl and the Bauhaus were bringing together the ideas of modern design in the 1920s, an inseparable union between design areas was fully achieved.

Thus, it is still possible to sit in a modern classic chair designed by Le Corbusier, within walls of his architecture, surrounded by his graphic works and interior design, and read a book that he designed. Le Corbusier, an authentic genius of twentieth century design, was not a member of any specific design movement, but his work bridged and transcended all of them.

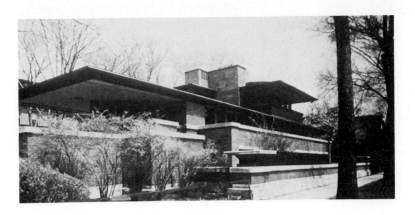

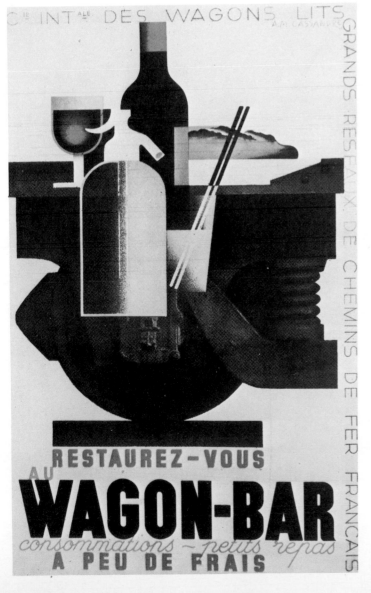

Frank Lloyd Wright's Robie house was completed in 1909 and became a major landmark in twentieth century architecture and design, with its cantilevered, asymmetrical planes.

Though the Cubist epoch ended in 1922, it continued to exercise a growing influence on graphic design, as demonstrated in this classic 1932 poster by A. M. Cassandre.

Although it predates Cubism, the Art Nouveau movement exercised little influence on the giant step toward modern design taken by Braque and Picasso. Unlike most trends associated with the modern movement, Art Nouveau was not dominated by painting. Even the painters most closely associated with the style—Toulouse-Lautrec, Pierre Bonnard, and Gustav Klimt—are identified with Art Nouveau primarily by their posters and decorative work. Art Nouveau was the first purely design-oriented movement, and its style was based on its sometimes elaborate surface decoration and its serpentine or curvilinear approach to form. It is perhaps not fair (nor totally accurate) to describe this style as the last gasp of ornamentation, but a comparison with the twentieth century trends that follow makes this conclusion seem appropriate.

Art Nouveau is important to the graphic designer because of the style it set for the printed page; its involvement with letterforms in printing and on shop signs; and its creation and early development of the modern poster. Graphic design has also been influenced by Art Nouveau's contribution to the related fields of fashion design, fabrics, and furniture, as well as the design of popular objects such as Tiffany vases and lamps, Lalique glassware, and Liberty prints.

Like many other design innovations, the advent of the modern poster was made possible by a technical breakthrough. Stone lithography in color became available toward the end of the nineteenth century and offered artists an opportunity to work directly on the stone, freed from all the rectilinear restrictions of traditional letterpress printing. Another influence that inspired this free use of space was the new popularity of Japanese prints.

16

DISCO MOD
NOUVEAU

The Art Nouveau spirit is obvious in recently revived letterforms above and in late nineteenth century posters of Paris, London, and New York. The 1899 poster of Jane Avril by Toulouse-Lautrec reflects the influence of oriental prints, as well as the curving lines, and casual lettering of Art Nouveau lithography.

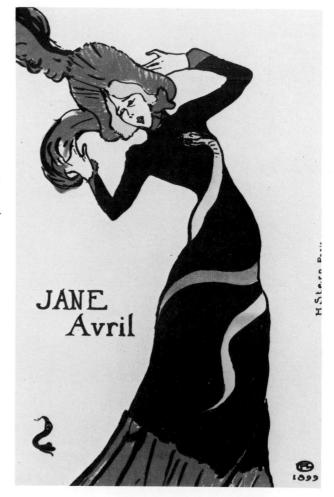

It is easy for designers brought up in the shadow of the Bauhaus and the formalism of the International Style to dismiss Art Nouveau as an over-designed negation of the basic principles of contemporary design, but decoration *is* a persistent influence in visual communication and graphic design. One only has to look forward twenty years to the Art Deco movement to find a continuation of the decorative approach to design surfaces.

Though Art Nouveau was more at home in the nineteenth century, traces of it can be found in the typographic layouts of the 1960s and 1970s. The swash characters of the Bookman type family, the roundness of Cooper black, and the revivals of old and ornate alphabets made possible by photographic lettering and typesetting are all evidence of the persistent influence of ornamental style.

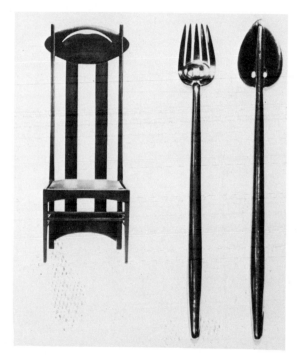

Charles Rennie Mackintosh was a unique designer of the Art Nouveau movement. His style was not as curvilinear as that of many of his contemporaries, but his work in architecture, furniture, and graphics had an important effect on later design developments, as demonstrated in his poster, the classic chair, and cutlery. Page from The Design Collection, Selected Objects, *The Museum of Modern Art, New York.*

Cubism sets the stage

Though it followed Art Nouveau, Cubism owes very little to the earlier style. In fact, aside from its acknowledged indebtedness to Cézanne and the Post-Impressionists, Cubism burst on to the art scene under its own creative drive.

The Cubists not only changed the course of painting, but their influence had a direct bearing on the future of the printed page. When Picasso and Braque abandoned the illusion of three-dimensional space, and reasserted the two-dimensional plane in painting, they established design as a principal element in the creative process. When they pasted printed fragments and wrappers on their canvases, they suggested new ways of combining images and communicating ideas. In addition, their use of printed and stenciled letters hinted at a new approach to letterforms and typography.

The Cubist movement was launched with the unveiling of *Les Desmoiselles d'Avignon* in Picasso's studio in 1907. During the brief period from 1907 to 1909, Picasso and Braque completed a group of paintings that firmly established the Cubist style. Within a few years, this revolutionary breakthrough was to change the outlook of many of the painters of Europe and sow the seeds of most subsequent movements in modern design. In 1913, some of the first paintings influenced by Braque and Picasso reached the United States in the now-famous Armory show. Among the works in that exhibition was Marcel Duchamp's neo-Cubist painting of the *Nude Descending the Staircase*, which was to be a forerunner of both the Futurist and Dada movements.

Two other important painters who fell under the influence of Cubism during this period were the Dutch painter Piet

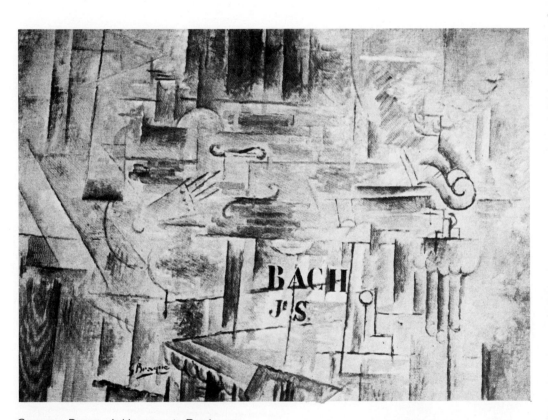

Georges Braque's Homage to Bach *was completed in 1912, when Cubism reached its fullest form. Like many Cubist paintings, it adds stencil letters to its design. Courtesy, Sidney Janis Gallery.*

18

Mondrian and the Russian Kasimir Malevich, artists who were to become instrumental in the forming of de Stijl and the Russian movements, which are loosely classified under the heading of Constructivism.

While the advance of the Cubist movement was interrupted by World War I, it was not eclipsed. In Spain, Picasso and Picabia continued to refine and extend the process, and, in neutral Holland and Switzerland, Cubism's evolution into other art forms continued. By the 1920s and 1930s, the new pictorial conceptions of Cubism had influenced successive generations of artists and designers. Cubist painting influenced the art of camouflage during World War I, and the movement's revolutionary approach to form was to have a less direct but significant influence on architectural and industrial design afterwards. This influence penetrated all phases of commercial and applied art and had a direct influence on 1920s poster and advertising design.

This illustration of An American in Paris, *painted in a neo-Cubist style by Miguel Covarrubias in 1929, was part of a campaign for Steinway pianos, art directed by Charles Coiner at N.W. Ayer.*

Futurism

The Futurist movement, like Dada, began in the years between the first Cubist paintings and World War I. The idea had begun to take form as early as 1909, when a group of young Italian artists and writers created the style to express their dynamic vision of the future. But it was only after their encounter with Duchamp's paintings and anti-art attitudes in Paris in 1911 and 1912 that the Futurists' work began to take on its ultimate visual form.

While the Cubists used geometric forms and a multiple viewpoint to portray still-life and essentially static objects, the Futurists followed the visual train of thought suggested by Duchamp's *Nude Descending a Staircase* and used a moving viewpoint to reveal dynamic action in a series of successive overlapped images. The movement was established by Marinetti, an Italian poet, who was soon joined by the imaginative painters Boccioni, Balla, and Severini—these artists translated his poetic ideas into visual images. Also included in the Futurist group was the visionary architect Sant' Elia, whose drawings of Futuristic cities forecast the look of 1920s architecture, particularly the skyscrapers in the Art Deco style.

Unlike the Dada movement that faded into Surrealism, Futurism met a tragic ending in the ashes of World War I. In 1916, both Boccioni and Sant' Elia died. Though the latter's dream of the future of architecture was doomed, his setbacks and streamlined curves resurfaced in many of the buildings of the 1920s and 1930s.

In spite of its abrupt ending, the Futurists did not sink without a trace. Through their manifestos, their ideas of machine-age esthetics began to influence the other design groups in Europe—namely de Stijl and the Bauhaus—during the

postwar years. Futurism's images and architectural ideas played an even more important role in shaping the modernistic style that came to be known as Art Deco.

Futurism is more important for its contribution to art than to graphic design. Though their visual ideas were to find graphic expression in the multiple-exposure photographs and photograms that became a design force in the 1920s, the Futurists paid little heed to the applied arts, and their typography followed the patterns of the Cubist and Dada typographers. Perhaps the single most significant contribution of this movement was its bridge to the Art Deco style that followed it.

21

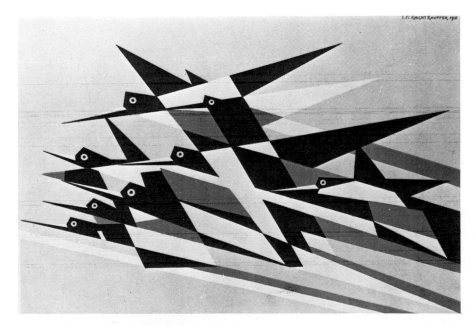

The historic canvas Nude Descending a Staircase *(far left) was painted in 1912 by Marcel Duchamp and is now in the Arensberg Collection at the Philadelphia Museum of Art. Its descending motion and ironical overtones had a profound effect on both Futurism and Dada. Futurism brought this sense of movement to graphic design in later posters, like the Italian poster at left and the* Early Bird *poster (above) by E. McKnight Kauffer, one of the great poster artists of the 1920s.*

Dada breaks the mold

If Cubism jolted the conventions of art and design, Dadaism went a step further and swept the rug out from under the very foundation of rational representation. The goal of the Dadaist was not so much to create a new style as to shatter traditional assumptions—to revitalize the visual arts by breaking all the rules. To this day, no one is sure who invented the word or what it means, though it may well have been based on the Slavonic affirmative *da, da* (yes, yes).

A protest movement that rejected all of the established values in society and the arts, Dada related to the popular wave of anarchism during World War I and applied its nihilistic attitudes toward art and design through poetry and paintings.

Dada was baptized at the Cabaret Voltaire in Zurich in 1916 by Tristan Tzara, a Rumanian poet; Hans Arp, the painter; and Hans Richter, an artist and later a film maker. Its birth, however, was perhaps first celebrated in the anti-art and anti-establishment attitudes that Marcel Duchamp developed in his brief flirtation with Cubism in 1912 and 1913. His *Nude Descending a Staircase* and *Bicycle Wheel* played a distinct role in setting the Dada style.

In addition to Duchamp and Arp, artists like Picabia and Max Ernst, the photographer Man Ray, and the poet Guillaume Apollinaire all made important contributions to Dada art.

This movement took place in a relatively short period beginning in 1912—Dada was declared dead and presumably buried at the *Bauhausfest* in Weimar, Germany in 1922. But Dada was more of a state of mind than an art movement, and its nihilistic ideas kept reappearing in the years that followed. While many of the early Dada group turned to

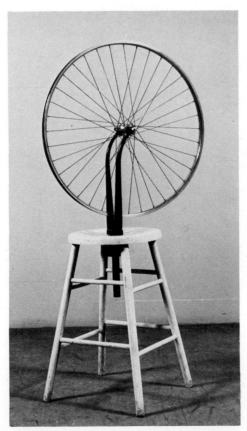

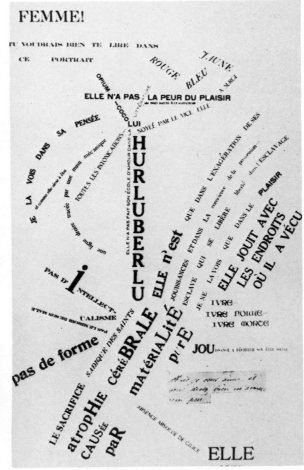

The 1913 construction, called Bicycle Wheel, *by Marcel Duchamp, shown above in a replica from Museum of Modern Art, New York, and the typography by Marius de Zayas from* Elle *in 1905 (right) are representative of anti-tradition and anti-art attitudes of the Dada movement.*

Surrealism, others continued to search out the absurdities and shocking incongruities that were the targets of Dada. In the late 1950s and early 1960s a resurrection of the Dada spirit found its way into the Pop Art movement in New York—Andy Warhol's Brillo boxes and Claes Oldenburg's limp telephone are only a short step removed from Duchamp's bicycle wheel.

Dada influenced graphic designers in two important areas: it helped to free typography from its rectilinear restrictions, and it reinforced the Cubist idea of letterforms as a visual experience. It also taught designers how shock and surprise can perform a significant role in overcoming viewer apathy. With all its absurdity, Dada must still be taken seriously for its influence on the other design movements that followed, such as de Stijl. The Constructivists and the early group of designers at the Bauhaus were also familiar with the principles and freedom of Dada, even though it was the role of all these movements as well as de Stijl to bring a sense of order and purpose out of the chaos that Dada had created.

23

The Dada influence will persist as long as designers and artists feel the need to protest, as this 1966 poster by Japanese designer Tadonari Yokoo proves.

Surrealism

Many studies of twentieth century design combine the Dada and Surrealist movements. While it is true that many exponents of Dada moved on to Surrealism in the 1920s, bringing Dada devices with them, the contributions of these two movements to graphic design are somewhat separate. While the designers of the Dada movement influenced graphic design by freeing it from restrictive attitudes toward form, the Surrealists contributed a new approach to visual images and content. Surrealist art reflects the subject matter, symbolism, and unpredictable juxtapositions of the unconscious, which we normally experience in dreams. Both movements owed a debt to Sigmund Freud and the unconscious imagery that his exploration of psychiatry advanced. But where the Dada approach was anarchistic, Surrealism combined revolutionary subject matter with art techniques that were often conventional, and even traditional, in their rendering.

Surrealism relied heavily on Freud's *Interpretation of Dreams*, which revealed the role of the unconscious as the repository of repressed sexual desires, and on James Joyce's *Ulysses*, which was published in 1922 and first used the stream-of-consciousness technique to reveal the subconscious thought of his characters. Both of these books influenced the surrealist painters and their continuing involvement with surreal subject matter in the communication of ideas—the Surrealist movement was formally established in 1924 by André Breton, who defined it as ''pure psychic automation by which one intends to express . . . the real functioning of the mind.''

Graphic designers benefited most from Surrealist painters like Max Ernst, who brought an extraordinary variety of

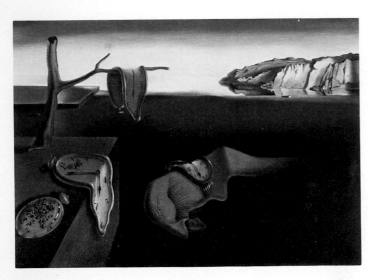

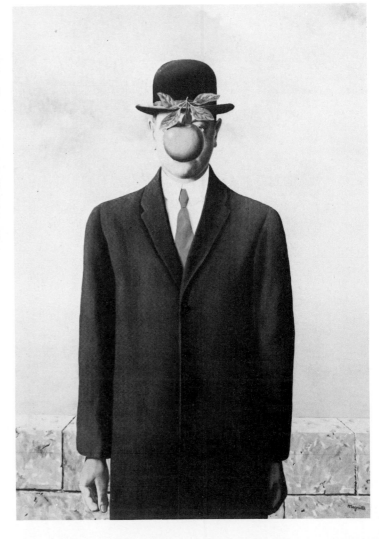

The Persistence of Memory *(above) by Salvador Dali (Museum of Modern Art, New York) is a classic example of the surreal landscape, and the* Son of Man *(right), painted by René Magritte in 1964 (private collection) is an example of surrealistic portraiture.*

24

techniques and a Dadaesque irreverence to the movement; René Magritte, who used a realistic style to paint objects in unfamiliar contexts; and Salvador Dali, whose academic style of painting gave a durable background to surrealistic nightmares. Two other Surrealist artists contributed to graphic form in a different way—Joan Miró and Hans Arp, both of whom worked in a more abstract vein, using forms and shapes that influenced design. Many other artists painted surrealistic images, but these are the ones who did most to reshape graphic thinking and graphic form.

Because of the close relationship of

Surrealism to emotional response and unconscious motivation, this movement has had a particularly strong influence on both visual communication and contemporary illustration.

25

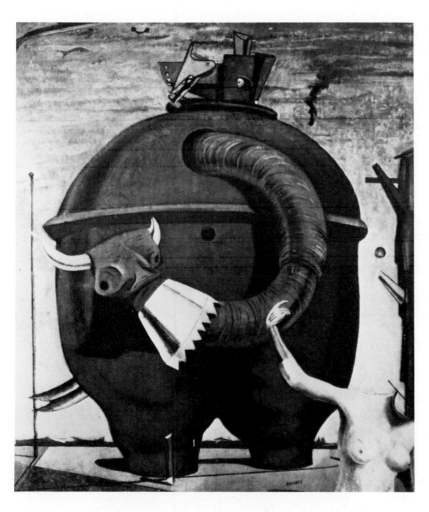

Max Ernst, who had been a leading painter of the Dada movement, turned toward Surrealism with this major painting, The Elephant Celebes, *in 1921.* The Tate Gallery, London.

Russian revolutionary design

The Stalin era did such an efficient job of erasing evidence of the modern movement in the Soviet Union that many contemporary designers are unaware of the magnitude of the debt owed to the avant garde ideas advanced by Russian designers in the years following the revolution. At the head of this movement was Kasimir Malevich, who had been in Paris during the early years of Cubism. By 1915, working toward ultimate simplicity in his art, Malevich had set the style for his Suprematist paintings composed of *fundamental suprematist elements*. These elements that he used in his paintings were the simple geometric forms of the square, circle, and triangle that were to play an important role in Bauhaus design.

Malevich created few graphic designs, and his contribution was largely in his early use of ultimate simplicity and geometric forms. His paintings had an important influence on other Russian designers whose work is more accurately described as Constructivist. In general, the Constructivists believed in the rational use of available material to create useful objects or to find solutions for communication problems. In the process, they rejected enduring aspects of esthetics for current utility. In reality, the word Constructivism is an umbrellalike label that covered a diverse body of work, and, in spite of both the isolation Russia went through during World War I and the intense border control of the new proletarian state, a great deal of information concerning this work passed between the designers of the Soviet Union and their European counterparts until the 1930s.

The avant garde artists of the Russian revolution included painters like Marc Chagall and Wassily Kandinsky, who later became a teacher at the Bauhaus,

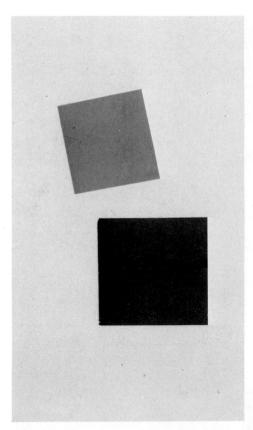

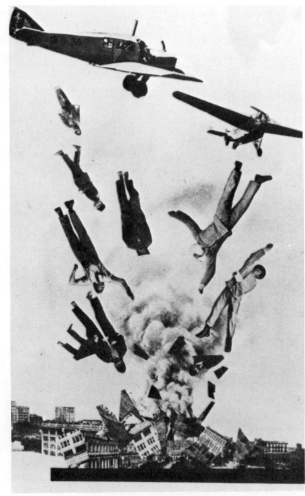

The design above is based on a 1913 Suprematist painting by Kasimir Malevich. The photomontage at right was created by Alexander Rodchenko in the early 1920s.

26

and graphic designers like Alexander Rodchenko, Nikolay Prusakov, and the Stenberg brothers. Perhaps the most important designer to emerge from the Soviet avant garde was El Lissitzky, who worked in Europe as well as Russia and whose contribution to the shape and form of graphic design is so important that he will be treated separately on the following pages.

One of the objectives of the Constructivists was to combine words and images into a simultaneous experience on the printed page as well as on film. This then-radical approach to visual images was destined to influence future attitudes toward the communication of ideas, and the word and picture approach served as a stepping stone toward photojournalism. This attitude also led to new visual techniques such as photomontage, photograms, and superimposition. These devices—widely used in the creation of their movie posters—expanded the potential of the printed page. Though many of the new ideas inspired the development of new graphic forms outside of Russia, the obscurity that overcame them in the 1930s meant that some of the ideas they suggested are yet to be fully realized in Western design.

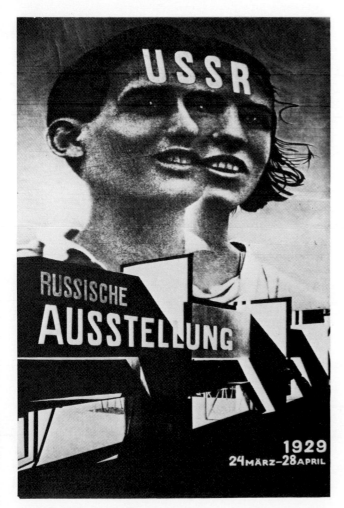

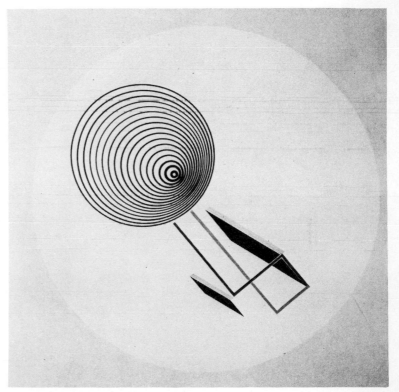

The 1929 poster at left, designed for the Russian Exhibition in Zurich, was executed by El Lissitzky, one of the most important pioneers of modern graphic design. Lissitzky's style of painting, which he called Proun *and described as an "interchange station between painting and architecture," is shown above in Free-floating Spiral.*

El Lissitzky

The Russian designer who did more than any of his countrymen to blend the Constructivist design experiments with the developing graphic ideas of the western European avant garde was El Lissitzky. He studied with Marc Chagall, later worked with Malevich, and visited Europe from 1922 to 1925, working and exchanging ideas with the designers of de Stijl and the Bauhaus. Though Lissitzky may not have been the most important designer of the Russian

Revolution, he brought a European refinement and elegance to Constructivist design. In addition, his ideas of asymmetrical typography and photomechanics had a profound influence on the 1920s style.

Just as the designers of Futurism and Dadaism broke the confines of conventional typography, designers like Lissitzky gave it a new form and a new order. In writing his new rules of typography and composition in 1923, Lissitzky emphasized the functional and visual approach to the use of letters, words, and systems in the communication of ideas. His concentration on the architecture of

printed matter and his emphasis on the total effect of continuity, rather than a preoccupation with the design of individual pages, provided a background for the later development of grids and design systems.

His typography and his rules of typographic use had a special influence on the work and writing of Jan Tschichold, a noted Swiss typographer and author of *Die Neue Typographie*, 1928, and *Typographic Gestaltung*, 1935. These books became bibles for many typographic designers, and Tschichold's contribution was not diminished by his later decision to return to more classic and traditional forms in

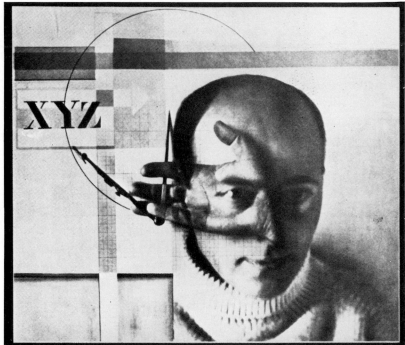

El Lissitzky assembled this graphic self-portrait in 1924 by combining several superimposed photographic elements to form a composition he called The Constructor. *The design at the left for the dedication page of a book uses the Cyrillic letter C to suggest vision.*

his own work.

In addition to El Lissitzky's typographic influence, he was one of the first designers to foresee the interlocking influence of photography and graphic design. Though Russian Constructivism was closely identified with photomontage, based on the collage of the Cubists, Lissitzky was more interested in the use of double-exposure, superimposition, and photogram techniques. His comprehension of photography as a part of the graphic structure made him the first graphic designer to understand that the camera and photomechanical means would eventually free the designer from metal type, engravings, and the tight rectilinear restrictions of traditional printing technology. He characterized this as a graphic revolution akin to the invention of movable type in the fifteenth century. Now, fifty years later, we are deep in the revolution Lissitzky foretold.

29

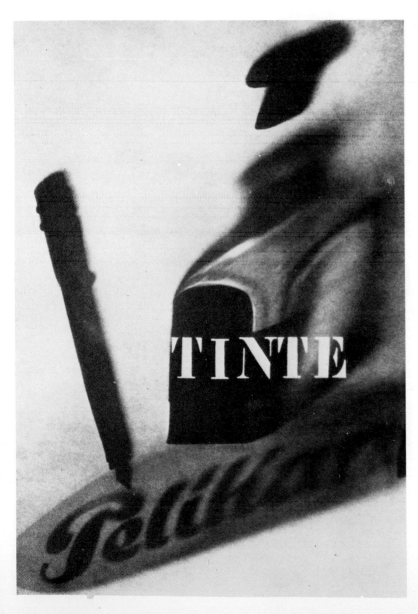

This famous poster design, created by El Lissitzky in 1924 for Pelikan in Germany, was one of the first to use the photogram in graphic design. The stencil letter reflects the influence of Cubism.

Alexey Brodovitch

After Lissitzky, there was one other quite different Russian whose work had a profound influence on graphic design—Alexey Brodovitch. While El Lissitzky was applying Constructivist forms to the promotion of the causes of the Red revolution, Brodovitch was healing the wounds he had suffered in the service of the White army. By 1920, he had escaped to Paris where, after a brief turn at house painting, he designed stage sets for Diaghilev's Ballet Russe and joined the impressive Paris poster movement. Though his decade in Paris coincided with the Art Deco movement, Brodovitch's personal style was sufficiently strong—and his natural antipathy to excess and ornament was so complete—that he successfully resisted the fashionable clichés of that period. Although his own work and the guidelines of his teaching cannot be directly identified with any of the formal movements in graphic design, he absorbed many of the best influences from these movements.

In 1930, Brodovitch came to Philadelphia, where he began a phase of his career that was to have a far-reaching effect on the shaping of American graphic design. His evening courses in graphics—which he called the Design Laboratory—influenced a generation of graphic designers first in Philadelphia and later in New York. The courses ran for 25 years, and a list of the students is a virtual *Who's Who* of design and photography in America. Among the photographers who studied under Brodovitch are Irving Penn, Richard Avedon, Art Kane, and Howard Zieff, to name only a few. The list of art directors includes Henry Wolf, Bob Gage, Otto Storch, and Helmut Krone. Richard Avedon, a close friend as well as a student, said of him, "From Brodovitch you will get no rules or laws. He teaches

Alexey Brodovitch was influenced by the classic subject matter that played such an important role in Art Deco design when he created this advertising illustration for the International Printing Ink Company shortly after his arrival in America in 1930.

by osmosis. There is nothing you can take away but the essence. Like an inherited quality, there is something of him in you for the rest of your life, and it keeps on growing.''

Brodovitch's own work included magazine, book, and advertising design, and his style and method of working were uniquely his own. For instance, he would often assemble his proofs and several different size photostats of the pictures, and, with his ever-present scissors, cut and arrange the elements under a sheet of glass until the final design emerged. Behind this somewhat haphazard method, there was an incisive mind, a keen eye, superb taste, and an unmatched approach to style.

Brodovitch used photographs with a skill and sensitivity that was the envy of other art directors, and the resulting designs commanded the respect of the photographers with whom he worked. His layouts had a style that was a curious blend of the oriental approach to order and space combined with a Continental sophistication. Brodovitch brought a rare sense of excitement and clarity to the printed page.

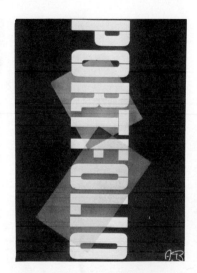

A cover and two spreads from a magazine called Portfolio, *published in 1950–1951, reveal Brodovitch's skill in page design. This publication was a culmination of the design ideas that had surfaced in the fertile 1920s and 1930s and was a forecast of styles to appear in the decades ahead.*

Many art and design historians look on the Art Deco style as more of a sideshow than a valid movement in the shaping of contemporary style. Certainly a large body of work created in this vein between the two wars seems to negate the dedication to simple presentation and functional form that the modern movement stands for. Some of its more extreme efforts produced work that is best described as kitsch, but the movement did reaffirm that man's affection for ornament and surface decoration cannot easily be swept aside.

We generally credit the origin of Art Deco to Paris and the Société des Artistes Decorateurs (the group that gave it its name), but its roots were many and varied. Though it owed a debt to Art Nouveau, Art Deco abandoned freewheeling curves for a more ordered geometric design. Its architects borrowed from Frank Lloyd Wright's Mayan-influenced ornamental blocks and spandrels but did not inherit his splendid regard for form. Art Deco's skyscrapers were often an extension of Futurist Sant' Elia's sketches. These architectural ideas carried over into other areas of design where there was also a preoccupation with Cubist ideas and the classic Greek revival.

The manifestations of Art Deco in the 1920s and 1930s were as varied as its roots. In architecture, especially in New York, Art Deco established the skyscraper style, a style neglected by architectural historians until a revival of interest in the 1970s, when the Chrysler building, for example, was seen in a new light. In interior design, Art Deco resulted in a style found intact at Radio City Music Hall.

Art Deco influenced the design of furniture and all of the related gadgetry of

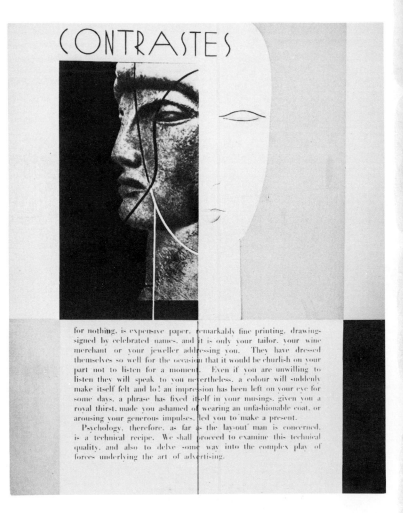

The typeface above is Bifur, *designed in the 1920s by A.M. Cassandre. The page at the right is from* Mise en Page *by A. Tolmer. Long out of print, this volume includes some excellent examples of design in the Art Deco style.*

32

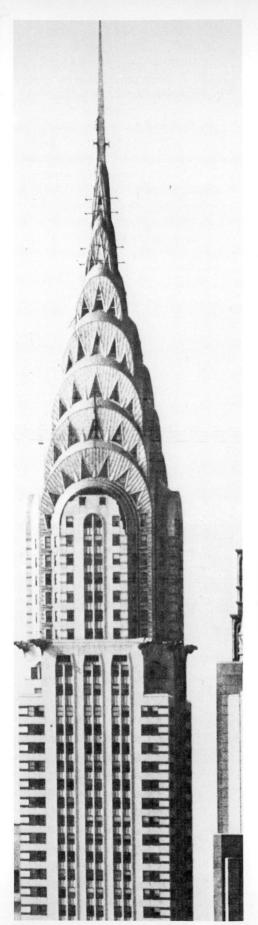

la vie moderne. The Art Deco era was a period of elegant packages, extravagant movie sets, ornate and stylish typefaces from Broadway to Prisma and Bifur, and borders with intricate corners. Art Deco was slick white and shiny black with chrome and bright gold accents. It was streamlined by day and lit with bands of neon at night. The scene was so spectacular and so frequently overdone that it is often difficult to tell the good from the bad.

The effects of Art Deco on the printed page are also difficult to assess but impossible to ignore. At its best, the style presented elegant designs that made good use of white space and widely leaded type lines often contrasted with the bold letter-spaced headlines. The illustrations of the Art Deco period were often well-drawn, pale-toned sketches or crisp line drawings, such as the ones by John Held, Jr. and Bret-Koch. On occasion, the designers indulged in geometric abstraction with Cubist persuasion and with varying success.

The Chrysler Building in New York was frowned on by the functionalists of design, but its ornament and chromium surfaces were the apex of Art Deco architectural style. The cover design above is Ashley Havinden's 1970 adaptation of his much earlier designs for Chrysler Motors in England.

De Stijl

The name of de Stijl (meaning literally *the style*) was peculiarly appropriate for the movement that in many ways set the style for twentieth century design. Its timing and its location were also fortuitous. During World War I, a few countries were spared the disruption and destruction of war. We have already seen how Futurism was destroyed in that period (see page 20), but there were three places in which modern design was able to move forward: in Spain, where Spanish Cubists Picasso and Picabia were able to continue their pioneer development of new forms though they were separated from Paris, its creative home; Switzerland, where the Dadaists, affected by the horror of the war but spared direct involvement, followed their irreverent course; and Holland, where the de Stijl movement was formed. During the war years the Dutch artists were able to set the stage in their neutral country and prepare the way for the later postwar European extension of the movement.

Among the leaders of de Stijl in the earlier years were two of the finest artists of the period—the painter Piet Mondrian and the architect J.J.P. Oud. However, the movement's expansive influence was generated by its principal founder and theorist, Theo Van Doesburg, prophet, painter, poet, critic, architect, typographer, and pioneer of modern graphic design.

We have already seen how design has benefited from the cross-fertilization of the many disciplines of the visual arts. Never was this coordination more important than when art came under the influence of advanced technology and scientific discovery—and nowhere was this more evident than in de Stijl.

The designers of de Stijl were noted for

34

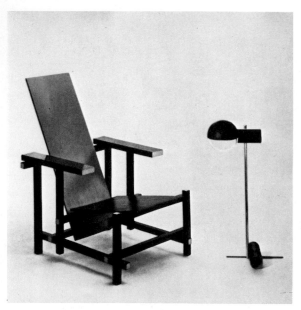

This 1917 chair and 1924 lamp were designed by Gerrit Rietveld, of the de Stijl movement. Page from The Design Collection, Selected Objects, *The Museum of Modern Art, New York.*

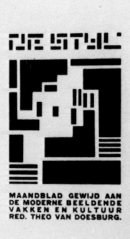

their precise and forceful division of space, sometimes set off by black lines; the tension and equilibrium they achieved through asymmetry; their bold and imaginative use of basic forms and primary colors; and the ultimate simplicity of their design solutions. They gave the name Neo-Plastic to their new approach to two-dimensional painting, and the term is generally considered to be synonymous with their overall style.

The free asymmetry of Frank Lloyd Wright's architecture had a strong influence on early de Stijl design. Van Doesburg and Mondrian both applied this approach to form in their paintings, and, when Van Doesburg extended it into typography, he turned a major corner in the creative development of modern graphic design. In its resistance to symmetrical solutions and ornament and in its growing awareness of modern industrial and technological ideas, de Stijl began to alter the look of the printed page. At the Bauhaus, for instance, the early typography seems to be directly derived from the models found in de Stijl.

The movement called de Stijl was one of the most verbal to arrive on the modern scene. Its name is derived from the magazine *de Stijl* that was published between 1917 and 1932, when its final issue appeared as a memorial to Van Doesburg, who had served as its editor

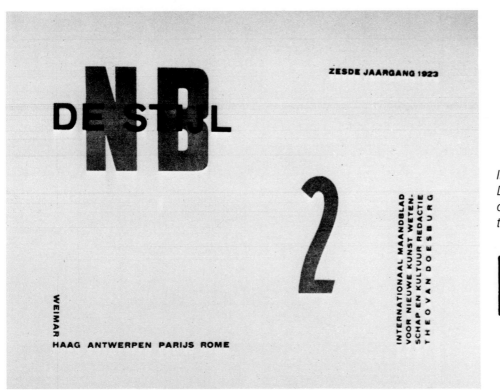

The first cover for the magazine de Stijl was designed in a basic symmetrical format by Vilmos Huzar in 1917; but, by 1923, Van Doesburg had redesigned the cover in the asymmetrical format above that was to be its style until 1932.

In addition to being a designer, Theo Van Doesburg was noted for his writing and design theory. Below is his formula for two-dimensional space.

until his death in 1931.

Van Doesburg was one of the first to recognize the fourth dimension as a design element when he identified the significance of the time equation (see next paragraph) in the films of Hans Richter, a member of the movement. In a 1926 article about neo-plastic design Van Doesburg wrote that, ''There is no doubt that an increasing desire for *visual reality* has caused the tremendous popularity of the cinema, illustrated newspapers, magazines, and photography. The desire for visual reality is part and parcel of the style of our times.'' He also pointed out that ''The printer's plate represents as real a means of communication as does the train. We already enjoy a plastic, film-technical reign over space and time, and we are not far from achieving a radio-mechanic (broadcast) elimination of the remaining dependence upon nature.''

De Stijl's revolutionary approach to form was summarized by Van Doesburg in 1928, when he wrote, ''The straight line corresponds to the velocity of modern traffic, the horizontal and vertical planes to the most subtle manipulation or the most simple functions of life and industrial technology.... Modern man challenges the orthogonal (symmetrical) form with an oblique (asymmetrical) one. These elementary renovations find their equivalent in the theory of relativity, in the new search for the nature of matter and a fresh attitude towards the unlimited intelligence and creative initiative of human beings.''

In the early 1920s, with the departure of Mondrian and many other early contributors, the Dutch period of de Stijl came to an end. Throughout Europe there was a postwar hunger for new design ideas, and, under Van Doesburg's leadership, de Stijl entered an international phase. This period brought together designers like El Lissitzky from Russia (see page 28), Frederich Kiesler from Austria, Moholy-Nagy from Hungary, and Hans Richter

36

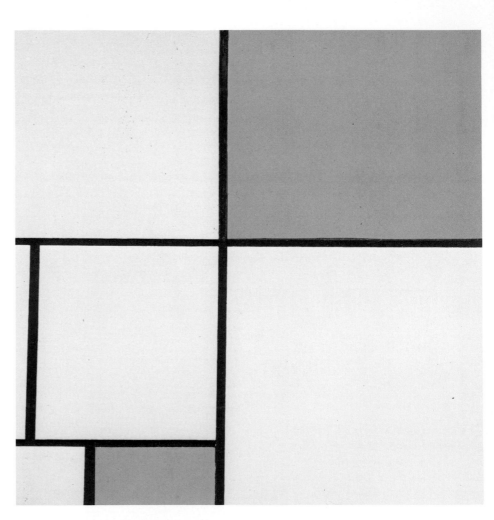

Piet Mondrian played the principal role in the formative years of de Stijl, and his paintings are a master file of asymmetrical divisions of space.

from Germany. The latter was a former Dadaist and abstract painter, whose experiments in abstract animation formed a foundation for modern visual techniques in film and television graphics.

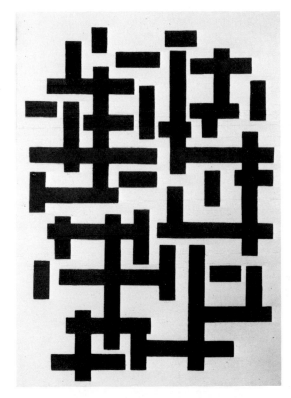

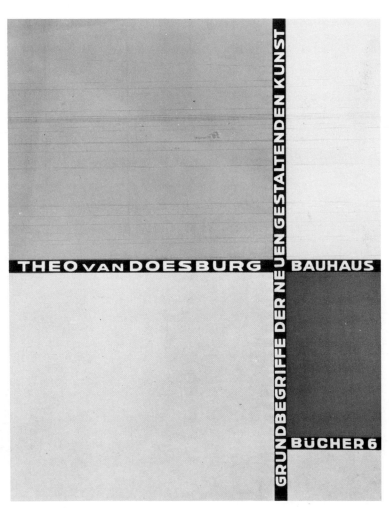

Theo Van Doesburg's paintings ran parallel to those of Mondrian. The compelling composition above of 1916 is a demonstration of the power of black and white. Though Van Doesburg did not teach at the Bauhaus, he had a profound influence on Bauhaus ideas. The cover design (right) was created by him for the sixth Bauhaus book in 1925.

The Bauhaus

No movement of modern design has had more written about it—and probably no movement has been so misunderstood—than the Bauhaus. In many ways, the Bauhaus was not a movement so much as a gathering place that brought together the accumulated ideas of the first two decades of the century in a school that was dedicated to a new training approach to the arts.

Walter Gropius had already achieved prominence as both an architect and leader of the Werkbund in Germany when he was invited to establish the Bauhaus at Weimar in 1919. His early years were devoted to assembling the superb staff that was to give the institution its distinction. The original objective of the Bauhaus was to train architects, painters, and sculptors in a workshop environment, and its success in these areas is beyond the dimension of this study. What does concern us is the gradual development, within this framework, of a significant training area in typographic and graphic design.

William Morris (see page 13) had initiated the craft approach to design fifty years before, but he was too much of a romantic to accept industrial technology Gropius added technological materials and processes to the craft workshops at the Bauhaus. The backbone of the Bauhaus system's creative approach was its preliminary, or foundation, course. The first foundation course was prepared and taught by Johannes Itten, an experienced art teacher who was responsible for the introduction of the "basic forms," but the course's true creative thrust came when Paul Klee taught the course briefly in 1923. The foundation course gained its final trend-setting form under the direction of Moholy-Nagy and Josef Albers from 1925 onward.

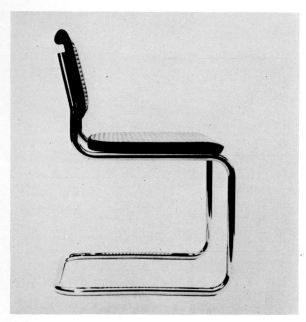

The design of objects was a very important Bauhaus course, and almost every piece of contemporary lighting owes its form to the designers of the Bauhaus. This classic tubular chair, designed by Marcel Breuer in 1928, has become one of the most popular chairs of the twentieth century. Page from The Design Collection, Selected Objects, The Museum of Modern Art, New York. *The advertising design at right was created by László Moholy-Nagy.*

From the publication of the organization's first proclamation in 1919, the printed page played an important role at the Bauhaus. This was due to the combination of a new emphasis on two-dimensional design in the foundation course and Gropius' desire to promote the Bauhaus ideas and image. In 1923, the Bauhaus Press was founded under Moholy-Nagy's direction, and by 1925 typography became a major course.

The influence of the Bauhaus on the design of the printed page is based on the contributions of five of the masters: Paul Klee, Wassily Kandinsky, Moholy-Nagy, Josef Albers, and Herbert Bayer. The best way to understand the new

dimension that this group brought to graphic form is to review their individual contributions.

Paul Klee, perhaps more than any other painter of the twentieth century, brought together visual and intellectual content. His work contains a wealth of direction and inspiration for the graphic designer, and his ideas are guidelines for an expanded vision. He brought to his paintings an intuitive appreciation of Einstein's view of space and Freud's revelations of the unconscious. In his concept of design, revealed in the *Pedagogical Sketchbook* of 1923, he holds that the space continuum begins with a point that moves to form a line that,

Herbert Bayer brought a humanistic approach to Bauhaus typography. The cover at the left is for one of the Bauhaus publications. The type is one of his many experimental alphabets.

in turn, moves to form a plane that, finally, moves to form a mass or volume.

Wassily Kandinsky, whose primary background, like Klee's, was that of painting, joined the Bauhaus in 1922 and served on the faculty for more than ten years. Kandinsky's approach to form developed during the Constructivist period in Russia (see page 26). As a result, he brought to the Bauhaus the intensely geometric approach to design that began with Malevich and was extended by the designers of de Stijl. He also brought the concentration on primary colors that had been explored and exploited by Van Doesburg and Mondrian.

László Moholy-Nagy was familiar with the de Stijl approach to simplified asymmetrical typography, when he joined the Bauhaus staff in 1923. He was also familiar with the experimental work of Man Ray in photographs and photograms, and the post-Cubist use of montage and collage in design. As a visionary, he prepared the way for a broader, more machine-oriented advance in Bauhaus thought; as a communicator, he helped extend the new design attitudes to the layout of the printed page in his innovative combinations of visual images and simplified typography.

Josef Albers began as a student of the

Bauhaus and went on to become the modern movement's leading teacher of two-dimensional design, first at the Bauhaus and later at both Black Mountain College and Yale University. In addition to his teaching, Albers' primary influence on graphic thought has been his sophisticated and intricate color theory, elaborated in his classic series called *Homage to the Square* and in his book, *Interaction of Color.*

Herbert Bayer, like Albers, studied at the Bauhaus before becoming a teacher there in 1925. By that time Moholy-Nagy had already pioneered the printing phase of the Bauhaus, but his typography had been essentially an extension of de Stijl.

40

abcdefq jklmnop

The letters above were developed as part of a plan by Herbert Bayer to eliminate capital letters. At right is an imaginative graphic illustration he created when he was with Dorland International in Berlin in 1930, before he left for New York.

It remained for Bayer to establish the Bauhaus style in typography. One of his more radical approaches to letterform was his attempt to eliminate the capital letter. Although the capital letter has remained in spite of the logic of his arguments, his efforts have gradually reduced the excessive use of capitals in German and English headlines, resulting in a simpler, more articulate use of type.

The Bauhaus is usually credited with the establishment of the International Style (Functionalism) in architecture and interior design and with setting the style for industrial design. These are no small accomplishments, but, as graphic designers, we are indebted to the Bauhaus for its coherent attitudes toward form and space and for the freedom they brought to the layout of the printed page. Even if today's designs do not resemble the prototypes of the Bauhaus, they continue to grow along the lines established there.

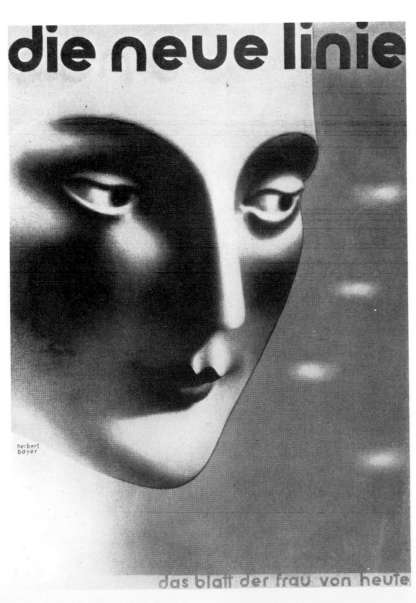

This cover of Die Neue Linie *was also prepared during Herbert Bayer's Berlin period. Though conceived in the late 1920s, both the typography and style are remarkably up-to-date.*

After the Bauhaus

By the time the Bauhaus closed its doors in 1933, modern design was a fully developed idea. Architecture evolved into the International Style (Functionalism), and industrial design became a new art form based on the framework established in the Bauhaus workshop. In graphic design, the asymmetrical approach to page design was firmly established; typography had found a new simplicity and directness of expression; and the growing importance of advertising had been recognized by the establishment of Bauhaus courses in advertising in the late 1920s. The modern movement placed a new concentration on primary color—red, yellow, and blue—and on primary form—square, circle, and triangle. And the designs of the Bauhaus typographers and the work of Van Doesburg, El Lissitzky, and Jan Tschichold had brought a new excitement and sophistication to page layout.

The problem of the decades that followed was to assimilate these dynamic ideas into the not-always-cooperative framework of commercial communication. At first, the early movement toward a free and informal organization of the page gave way gradually to a more ordered and structured design. Then, in the 1960s, some contemporary graphic design turned back the clock. In a relatively short period, design dipped into the decorative grab bag of Art Nouveau and, later, Art Deco. On the whole, these efforts produced only fashionable and ''trendy'' (a word invented for this period) solutions. The few good pieces that resulted from this instant nostalgia continued to apply the dictates of simplicity and of clearly defined form inherited from the pioneer designers and typographers of the modern movements.

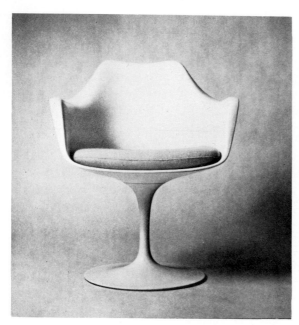

By 1957, when Eero Saarinen designed his famous pedestal chair, curved form was beginning to modify the dominant rectilinear style. From The Design Collection, Selected Objects, *The Museum of Modern Art, New York.*

Will Burtin's cover design at the right marked the end of a remarkably creative decade in American design.

42

Meanwhile, the fine arts movement that was to answer to the name ''Pop'' mixed the spirit of Dada with images borrowed from the most commercial kind of graphic design, particularly in packages and advertising. Because this art was already a parody of graphic design, it had only a slight influence on contemporary communication.

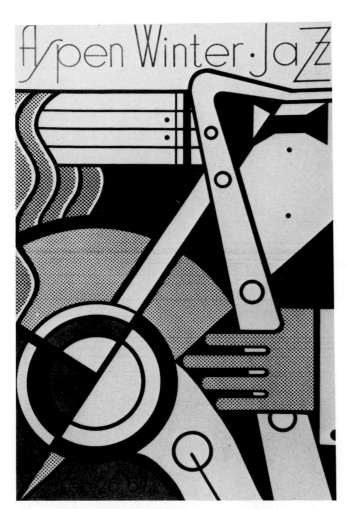

The Aspen Winter Jazz poster by Roy Lichtenstein for Posters Originals came at the height of the Pop Art period. He added the oversize dots of comic strips to an Art Deco inspired composition.

Summary: A measure of style

The preceding pages have reviewed the historical formation of modern design, beginning just prior to 1910 and moving to the present. By 1920, following the cataclysm of war and revolution, the critical formative period of that movement had been completed. The Bauhaus was only one year old in 1920, but the artists, architects, and designers who founded this trend-setting school were able to take the ideas developed in the previous decade and synthesize them into what was to become the modern style.

What is style? Up to now, we have taken the term for granted and not attempted to take an accurate measure of its meaning. The dictionary defines style as "a particular distinctive mode or form of construction or execution in any work or art." When a layout is successful, we consider its style to be a blend of the accumulated experience, personal taste, and creative force of the designer. A careful distinction is needed between the style arrived at by designers working toward a common objective and the merely fashionable solutions that grow out of imitation.

What is modern design? This is also difficult to define, because it exists in an intensely visual and varied body of work. Its essence is perhaps revealed in some of its clichés—the dictate of Louis Sullivan that "form follows function" and the later expression, identified with Mies van der Rohe, the last director of the Bauhaus, that "less is more." Beyond those overworked paraphrases of the word "simplicity," the modern movement was also concerned with a revitalization of factors now considered basic: the primary colors, red, yellow, and blue; the primary forms, square, circle, and triangle; and their three-dimensional counterparts, cube, sphere, pyramid, cone, and rod. There is another

Twentieth century design

The diagram at the right summarizes the movements that shaped modern design from the turn of the century to the mid-1930s. There is little precise information upon which the beginnings and end of some of the movements can be based, and World War I had varying effects on each of the styles. The revival of some influences, particularly Art Deco, Art Nouveau, and Dada, blurred the boundaries of some movements; but the chart provides the designer with an opportunity to study the relationship of these influences to each other in the critical, early decades of modern design.

reason that modern design defies precise definition. In a time of accelerated movement and change, this design approach shifts with each technological development—each new idea that leaves the drawing board is instantly communicated to the world.

In reviewing the growth of modern style, we covered nine essential movements that contributed to its form: Art Nouveau, Cubism, Futurism, Dada, Surrealism, Constructivism, Art Deco, de Stijl, and the Bauhaus. *How did each of these movements contribute to the modern style of graphic design?*

Art Nouveau. This was the prelude and,

some would say, the false start of the modern movement. In addition to its general emphasis on ornament and surface decoration, this movement had some direct influence on graphic design—it marked the beginning of posters as an art form in the work of Beardsley, Bonnard, and Toulouse-Lautrec. These posters became a potent force in the formation and transition of artistic style to other forms of applied art. In publication design, page layout still adhered to traditional and classic patterns, but its typographic ornament, letterforms, and illustrations provided a pattern for future graphic ideas.

Cubism. No more revolutionary art event

occurred in the twentieth century than the advent of Cubism, and no event had a more enduring effect on the visual development of communication. Cubism influenced graphic design through its use of collage and assemblage, through its free use of letterforms as plastic elements, and through its tradition-breaking approach to representation and form. Within a few years of its introduction in 1907, it had altered the design approach of de Stijl, Futurism, Constructivism, and a generation of painters in every corner of the world.

Futurism. The critical bridge between Cubism and Futurism was supplied by Marcel Duchamp in his now-classic *Nude* **45**

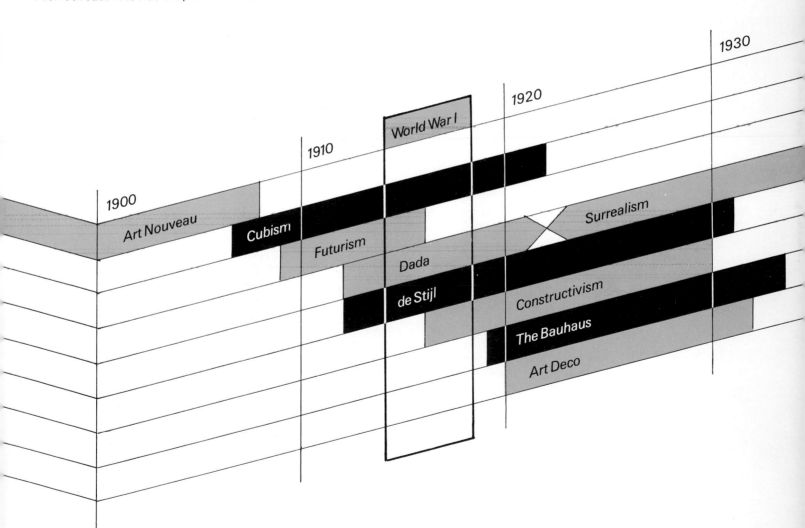

Descending a Staircase and his *Coffee Mill,* both painted in 1911. The former applied Cubist form to motion and the latter introduced machine mechanics as a design element. In their preoccupation with machine movement, the Futurists made their most telling graphic contribution.

Dada. Inspired by Duchamp's irreverence and boundless imagination, the Dada movement spread across the art world. Its persistent challenge and nihilist attitude toward the sacred cows of art had two major influences on modern graphic design: first, it taught designers that humor and shock value could often gain a viewer's attention and overcome

his apathy; and second, from Dada's freewheeling experiments in typographic communication, designers learned to reappraise their typographic formulas.

Surrealism. Under the growing influence of the ideas of Sigmund Freud, many of the early Dada artists moved on in the 1920s to shape a new kind of illustrative art based on the unconscious. This shift formed a foundation for a new approach to graphic imagery, drawn illustrations, and photographs, and provided a major source of ideas in visual communication.

Constructivism. In their break with traditional approaches, the Dadaists and

Surrealists created considerable chaos in communication. On the other hand, Constructivism, as an early voice of the Russian revolution, was destined to begin creating a new sense of order in design, along with de Stijl. By utilizing photomontage, collage, and free typography in the applied arts, this movement helped to create the foundation for a new approach to visual communication that was to take its final form under the guidance of de Stijl and the Bauhaus.

Art Deco. This movement, which in many ways ran counter to the trend toward simplicity in modern design, brought surface decoration back into the applied

46

Lester Beall's 1938 cover design for a brochure he prepared for the Sterling Engraving Company reflects the precedent-shattering typographic experiments of both the Futurists and the Dadaists, as well as the sophisticated asymmetrical approach to form of de Stijl and the Bauhaus.

arts. Under its influence, a large body of the printed matter of the 1920s took on a look of streamlined slickness that began to give way to the more direct ideas of the Bauhaus typographers by the mid-1930s. Like Art Nouveau, this style is often popular with students who are intrigued with its nostalgia and variety of options, but, like any superficial style, it is not without its dangers and it is capable of creating communication design that fails to communicate.

De Stijl and the Bauhaus. When the Bauhaus opened its doors in 1919, Piet Mondrian had moved from Cubism to first his Neo-Plastic approach and then to simplified asymmetrical painting, and

Theo Van Doesburg had refined typographical presentation and asymmetrical page layout in de Stijl. By the time the Bauhaus closed in the early 1930s, these ideas had been extended to include all forms of printed matter—magazine covers, advertisements, editorial layouts, books, and brochures. Though much of the work was experimental, many of the finished pieces produced are as modern and effective today as they were in this critical developmental stage of graphic design.

47

Milton Glaser's poster of Bob Dylan was created for art director John Berg at Columbia Records. Like the design by Lester Beall on the facing page, it is not imitative of any past or present style; but it does convey some of the spirit of Art Nouveau in a contemporary frame.

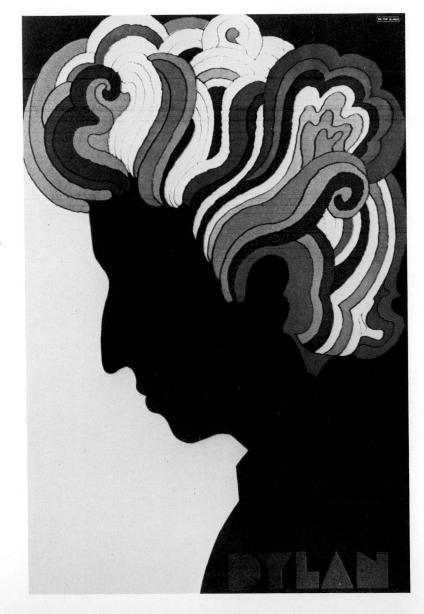

form

Form: Defining structure

When primitive man first placed two stones together, he may have made the first move in the development of form. It is even conceivable that in some strange, intuitive way, he may have arrived at an arrangement of his stones that could be accurately explained by principles of proportion that were to be discovered and formulated many centuries later, principles that to this day are not totally understood.

Archaeologists probing the early beginnings of civilization are constantly encountering evidence of some innate sense of organization and a natural appreciation of proportion. In some of the earliest cultures, there is evidence of often complex formulas that hint at a relationship between mathematics and form. In the earliest expressions of visual communications, there was a natural gravitation toward the symmetry of nature; but we also occasionally encounter examples of the forceful tension and equilibrium of asymmetrical form.

By the emergence of Greece and the other Aegean civilizations, this sense of form had become a highly articulated system: by the fifth century B.C. the architects of Greece were able to isolate the principle of proportion based on the division of a line into an extreme and mean proportion. Later this became known as the golden section, on which the main measurements of the Parthenon are based. The golden section has played a role in nearly all efforts to create design systems and grid structures since that time—it was used by Albrecht Dürer in his fifteenth century analysis of the alphabet and by Le Corbusier in his twentieth century design system he called the Modulor. The golden section was even used to explain the music of Béla Bartók.

51

Though there is ample evidence that this basic system of proportion is valid, it cannot begin to take into account all aspects of form. It does not adequately explain the design potential of the square, nor does it begin to come to grips with the many effective and varied forms that can be found in a study of natural objects like the snowflake, the shell, or the snail. It does not begin to explain all the complex design rhythms that exist within the form of leaves. Because our vision does not respond in a precise, predictable, or structured way, we cannot begin to solve all of our creative design problems in the terms of a structured theory. When we look at the simple, asymmetrical design of a Mondrian painting and compare it with the equally beautiful, but complex, fractured forms of a Braque painting in the Cubist style, we begin to sense the inadequacy of systems.

Mathematical laws of proportion can be valuable in ensuring that all elements of a design knit together to produce a unified and sometimes unique solution. However, this adherence to predetermined systems of proportion alone cannot supply a creative solution. Most design ideas are arrived at quite independently of such rules and regulations, and it is a trained eye and alert mind that will most often lead us to exciting design solutions.

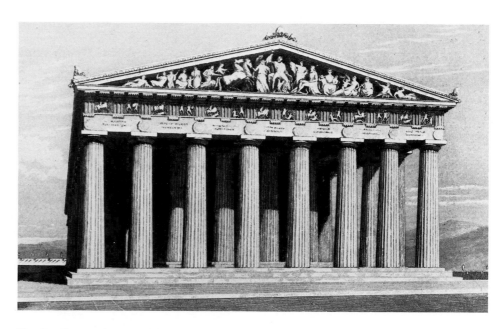

The Parthenon is probably the most over-analyzed work of art in history. While it is true that Ictinus used the golden section to determine its dimensions, it is also reasonable to assume that many of the esthetic judgements he made cannot be explained by mathematical formulas.

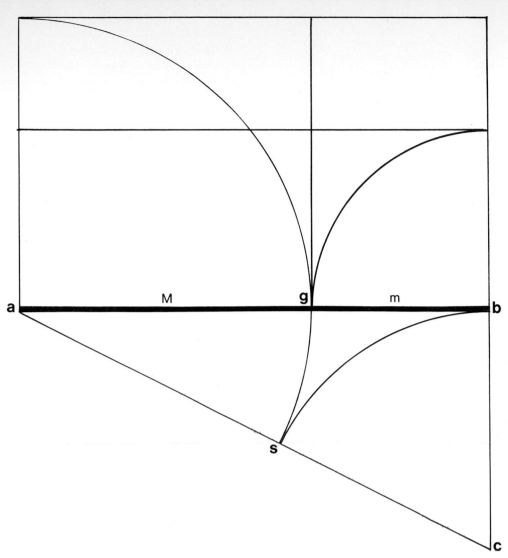

The diagram at the left shows one way in which a golden mean can be determined and used to construct a golden rectangle. Starting with the line (ab) a triangle is formed using one-half the width of (ab) as the vertical (bc). The hypotenuse (ac) is then divided by swinging a curve on axis (bc). Using (a) as a center point, swing a curve on axis (as). Where this curve bisects (ab), it will divide the base line into an extreme mean (M) and a minor mean (m). By using (M) as the short side of a rectangle and (ab) as the long side, we have created one version of the golden rectangle.

Symmetry: The classic ideal

The early Mediterranean cultures of the Egyptians, the Greeks, and the Romans set a style that was firmly entrenched in formal balance. Their monolithic structures executed in stone and marble with centered entrances dictated a form based on a central axis with an equal balance of elements on both sides.

This dedication to classic symmetry grew out of the block-on-block construction; the enclosed space that resulted; the

need for a fixed entrance; and the philosophical and religious purpose of many of the buildings. For many years, Western architecture followed the lines laid down by Phidias, the master designer of the Acropolis, and his followers. But in the sixteenth century, when the printed page was in its infancy, Andrea Palladio extended this acceptance of classic balance to an extreme in which the left and right wings of a building mirrored each other, sometimes without regard for need or function.

This architectural formalism had a profound influence on the form of inscriptions and early manuscripts that,

in turn, directed the design of the printed page. If the occasional chiseled inscription or hand-rendered scroll ended up with letters that are aligned at the left with uneven margins at the right, it was more a matter of convenience than intent. The varied nature of the material to be assembled on the printed page, the varied line lengths required by poetry and drama, the need for ornamental initials and decorative illustrations, all began to nudge at the formal foundations of early pages in type; but the primary dedication of the scholar / printers of Venice, who were the pioneers of graphic design, was to symmetrical balance. When the design moved away from its central axis, decorative borders were

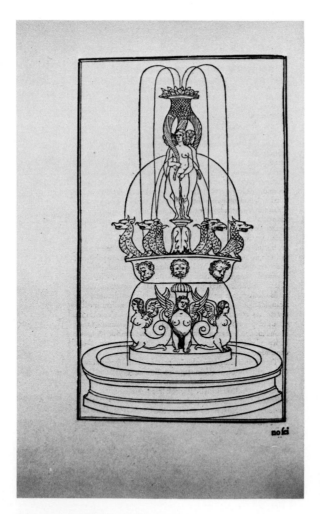

These pages from the Poliphilus, *published by Aldus Manutius in Venice in 1499, are laid out in a near-perfect symmetry, that extends to the illustration.*

often employed to bring the result back to formalism. Like the walls of a classic building, they enclosed and organized the space in an unbreakable pattern.

It was not until the twentieth century that asymmetry began to be appreciated as an optional force in architectural and graphic design, but it did not diminish the importance of symmetry as a creative approach to form. Symmetrical balance has produced page designs of rare beauty, and the esthetic conditions that inspired classic page design continue to set the pattern for a fair proportion of contemporary design.

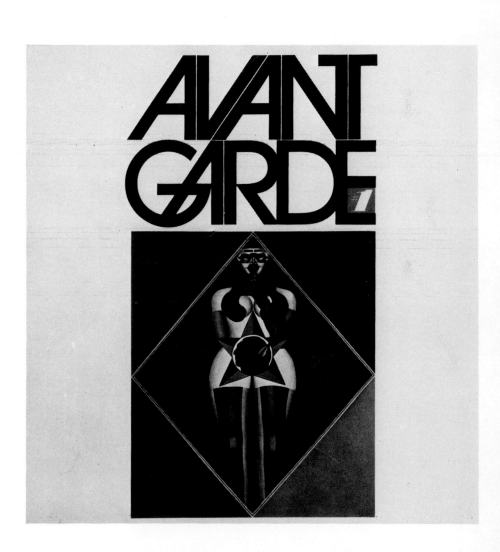

Symmetrical form still has a place in contemporary design. This cover, designed by Herb Lubalin for Avant Garde *in 1972, is set on a central axis. Aside from the tension of the slanted strokes of the letters, the design is in symmetrical balance, as is Richard Lindner's powerful painting called* Ice.

Asymmetry: The oriental order

While the Roman empire was spreading the concept of classic symmetry across the European continent, a new view of architectural form was developing in Japan. Drawn by necessity and climate to wooden framed structures instead of stone, the Japanese designed their buildings to open outward toward nature rather than inward to embrace the interior space. The result of this different approach was a different form based on a carefully and deliberately planned asymmetrical design.

Several aspects of construction inspired the off-center approach. The sliding screen for ventilation and access was, by the nature of its function, asymmetrical. This opening, unlike the classic doorway, moved to varied positions and was often located on one side or another of the building façade. The post-and-beam construction—so logical when building with timber—made it possible to create cantilevered planes and extensions of roof overhangs that would have been impossible in stone or masonry construction where the essentially symmetrical vault and arch were more appropriate.

While Western design was constructed around the central axis and golden mean, the Japanese construction was based on modular systems. One of the simplest and most frequently used modules was the tatami mat, many of which lined the floors of Japanese houses. They were made of igusa straw, covered with bound reeds, and bound together by black tape. The tatami mat measured about 3′ x 6′ (.91 x 1.83 m), and its double square proportion lent itself to varied patterns and arrangements when the mats were laid in groups. These patterns, in turn, often set the dimensions of the interior space and influenced the overall proportion of the design.

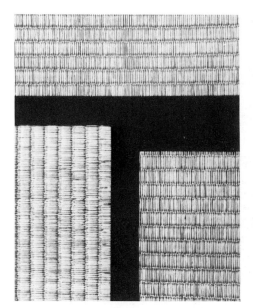
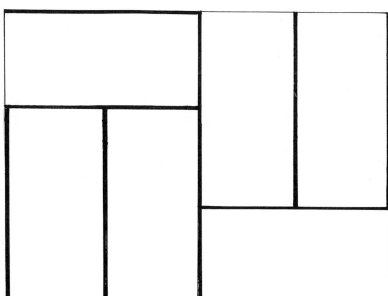

Modern design owes a considerable debt to the centuries-old Japanese asymmetrical division of space in architecture and interior design. A basic module of Japanese form is the tatami mat, shown in a close-up at the left and in one of its many patterns above.

Behind this unique approach to space in Japanese architecture and art—in which fluid, open space was as essential to the design as the objects in that space—was a philosophy that perceived the individual not in opposition to the outside world, but as part of it. Form and space were interdependent and inseparable. It is not difficult to see how this attitude dovetailed into twentieth century design—the Japanese natural instinct for the organization of space and for pristine order is reflected in the refined but simple form of their art.

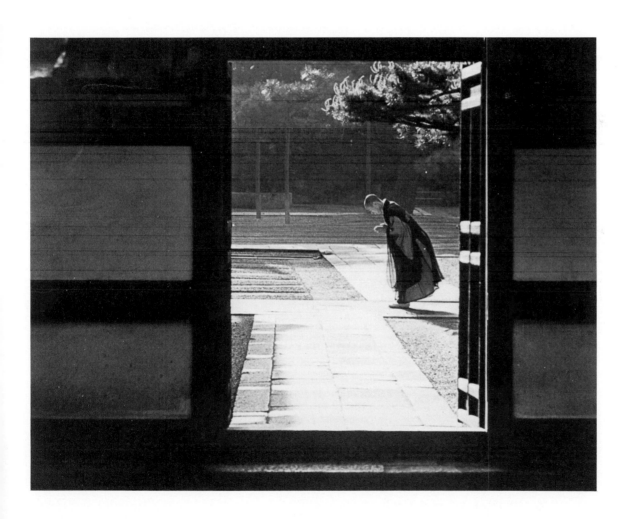

Asymmetry moves west

There is a growing realization that modern Western design owes a sizable debt to the simplicity, order, and asymmetrical division of space that has characterized Japanese art and architecture for many centuries. It is well known that from the late nineteenth century onward, Japanese prints had a significant influence on the form of Western painting and the graphic arts. However, the influence of Japanese architectural design on the development of plastic form in the West is less well-documented.

In 1893, Frank Lloyd Wright, then in his twenties, made several visits to the Japanese pavilion called Ho-o-den at the Chicago World's Fair. This pavilion, a rare example of Japanese traditional architecture, demonstrated the oriental respect for space and the unique asymmetrical division of exterior planes with dark wooden accents. A few years later, Wright designed and built a new home for the Ward Willets family in Highland Park, Illinois. Not only did the plan of this house, one of the early prairie houses, substitute flow for Palladian symmetry, but, more important, the façade of the house reflected the Japanese divisions of space that Wright had seen in the Ho-o-den pavilion.

It was the nature of Frank Lloyd Wright's genius that he never acknowledged influences on his own work or bothered to accept the compliment of his influence on others. Yet even a casual review of his work and the work of other twentieth century designers confirms such influence in both directions. The Japanese influence on the Ward Willets house in Illinois might have been of no great importance to modern form, however, had it not been for the Wasmuth publications of 1910 and 1911, which brought the early work of

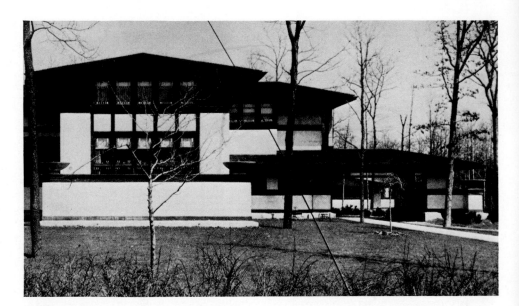

One interesting transition of Japanese form to twentieth century design lies in Frank Lloyd Wright's consuming interest in Japanese architecture and prints. The Ward Willets house (above) is generally considered to reflect this oriental concern. The house in turn became one of the features of the Wasmuth publications circulated in Europe in 1910, where it influenced the art and architecture of de Stijl in the decades that followed.

58

Wright to the attention of European architects and artists. There is no question about the powerful influence these publications had on the modern movement in Europe, but one of the most unusual influences has not been clearly and completely established. This was Wright's influence on the division of linear space developed by Van Doesburg and Mondrian in the de Stijl movement in Holland. By 1918 both artists were using dark lines to divide their canvases in patterns that suggested Japanese asymmetrical design.

Vincent Scully, Jr., a leading architectural critic who has explored this apparent influence from an architectural

historian's viewpoint, sums it up in his book *Frank Lloyd Wright* with these words, "In my opinion the Dutch de Stijl movement itself owed even more to Wright's interwoven striping details and plastic masses than it did to French Cubism." In any case, whether this suggested path—from Japanese traditional architecture to Frank Lloyd Wright to Mondrian—is a true course or a mere coincidence, the effect of this breakthrough on the developing modern approach to form is beyond question.

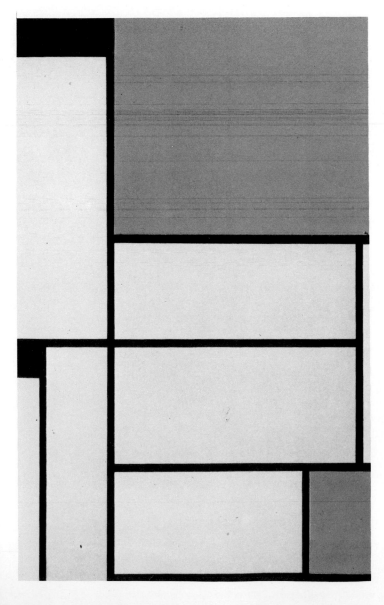

Have you heard? This sport shirt can go everywhere—even into the washing machine. It washes easily, dries quickly, and if you want to bother ironing it, it won't take more than a minute. You never have to "put it away"—because moths just don't go for it. And—maybe this is the biggest miracle—it looks and feels the way a sport shirt should—soft and luxurious, but with enough body to have a shape of its own. The reason for all this good news is an amazing new fiber called Acrilan. If you're lucky, next weekend *you'll* be wearing a shirt of Acrilan too.

ACRILAN.

This 1952 advertisement for Acrilan, designed by Robert Gage of Doyle Dane Bernbach, echoes the neo-plastic form of Mondrian's painting, left.

The Mondrian influence

When contemporary designers assess the continuing value of the influence of Mondrian and the de Stijl movement on graphic design and page layout, they tend to exaggerate the rigidity and geometry that these paintings may sometimes suggest. Such an appraisal is unfair to both the original material and to the imaginative and creative potential that exists in the application of the Neo-Plastic approach to space.

It is sometimes difficult to see the plastic, spatial beauty of a Mondrian painting behind the black bars he used so effectively to emphasize the carefully proportioned space just as it is, at times, difficult to see the forest for the trees. While the influence of these bars on modern typography was of considerable importance, Mondrian's most significant contribution to graphic design lies in the purity and simplicity with which he approached the two-dimensional surface of his paintings.

A study of the paintings he produced in the 1920s is a comprehensive lesson in the almost limitless possibilities for the asymmetrical division of space. This lesson, heeded by countless painters, had its most profound influence on the new generation of graphic designers who were inspired by the Mondrian breakthrough and who demonstrated in their layouts what a wild and unrestricted field he had opened up to contemporary design and layout.

60

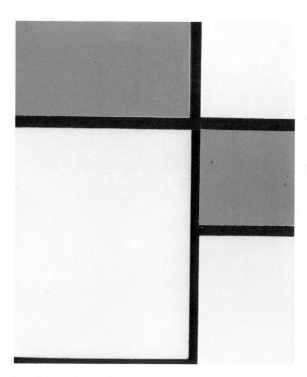

The Mondrian influence on contemporary design took many forms that were not always traceable to his precise patterns. The layout, right, by Carlo Vivarelli with a photograph by Werner Bischof is an example.

To the executives and management of the Radio Corporation of America:

Messrs. Alexander, Anderson, Baker, Buck, Cahill, Cannon, Carter, Coe, Coffin, Dunlap, Elliott, Engstrom, Folsom, Gorin, Jolliffe, Kayes, Marek, Mills, Odorizzi, Orth, Sacks, Brig. Gen. Sarnoff, R. Sarnoff, Saxon, Seidel, Teegarden, Tuft, Watts, Weaver, Werner, Williams

Gentlemen: An important message intended expressly for your eyes is now on its way to each one of you by special messenger.

William H. Weintraub & Company, Inc. Advertising 488 Madison Avenue, New York

This effective advertisement designed by Paul Rand combines asymmetrical form with a headline that spells the letters RCA in the signs of the Morse code.

Balance

Balance is the key element in the success of both symmetrical and asymmetrical designs. The equilibrium of a formal layout in the symmetrical style is easy to understand—with the center of the page serving as a fulcrum and the content uniformly divided on either side, it is relatively simple to create. The asymmetrical design on the other hand, with its multiple options and its off-center stresses, requires considerable skill to execute.

Toward the end of the 1920s, Parisian printer A. Tolmer produced a remarkable book called *Mise en Page, The Theory and Practice of Layout*, which conveyed a great deal of the excitement and innovation in design during that eventful decade. In fact, the book was a tour-de-force in design ideas and printing techniques. Although by de Stijl and Bauhaus standards it might be considered flamboyant and lacking in design purity, *Mise en Page* does reflect many of the typographic ideas advanced by Van Doesburg, El Lissitzky, and the Bauhaus typographers. However, its design was often more akin to the Société des Artistes Decorateurs Français and the style we have come to call Art Deco than it was to the Bauhaus style. In spite of this slight lapse in design purity, *Mise en Page* contained a suggestion of almost every design idea that was to occur in the half-century that followed. In addition, Tolmer's book contained samples of advanced photographic techniques and samples of printing techniques and special effects that would be difficult to duplicate today.

Mise en Page contains some provocative words about layout and design, and Tolmer's definition of balance is worth repeating here: ''Like skating or walking the tight-rope, the art of layout is an art of balance. It cannot, however, be expressed merely as a mathematical

The pages above from Mise en Page *demonstrate the tension and the equilibrium of asymmetrical design applied to symmetrical objects. The illustration at the right by Saul Bass for Tylon Products, through the Blaine Thompson agency, indicates with near perfection the opposing forces in an asymmetrical balancing act.*

calculation. The tight-rope walker steadies herself with her parasol rather than with the aid of a formula. The sense of stability; the right and wrong way of doing anything; the amount of air that enables the earth to breathe; the most satisfactory way of combining the elements of a theatre set, the page of a book or a poster; all these things are essentially a matter of feeling.''

The reason that the performance of Tolmer's tightrope walker is exciting rests on the unsureness of her journey—the threat of falling is always there. It is in this tension and implied movement that the asymmetrical layout gains its strength.

Contrasts of value and color

"Contrast is the mark of our age," wrote Theo Van Doesburg, the Neo-Plastic prophet of the de Stijl movement in the early 1920s. Over fifty years later, a student of modern graphic design does not have to look far to sense the overriding importance of this element in layout. The contrasts of dark against light and large against small, the contrast of mood in subject matter, and the punctuation of space by strong accents all contribute toward the dramatic presentation of graphic material. Jan Tschichold, often considered the father of modern typography, identified contrast as "the most important element in all modern design."

If we owe a debt to Japanese art and architecture for the asymmetrical approach to form, we are also in their debt for their early exploration of value relationships in the monochromatic sumi (ink) painting. In graphic design, the white of the paper and the darkest black that printing ink can provide are the polar forces of the design process. When a dark (low-key) image is juxtaposed with a light (high-key) image, the resulting contrast enhances both images and adds visual impact to the design. On the printed page, value contrast takes many forms: it is the relation of boldface and light line in typography; it is the negative, or reversed, image played against the positive image; it is the accent of a black image set in white space.

Contrast does not depend on multiple images within a layout, but may be expressed in the values of a single picture. There are two factors of visual perception that enhance the effectiveness of contrast: the illusion that a dark object will appear closer to us than a light object; and the way in which a dark object will seem even darker in a light area and a light object even lighter in a

64

The imaginative spread above by Bradbury Thompson for Westvaco Inspirations, published by the Westvaco Corporation, contrasts the dark tones of a photogram against the high-key photograph at left.

dark area. In the illustration below, the gray bar is actually constant, but its tone seems to vary as the background tone moves from light to dark.

When color images are involved, the designer is forced to consider chromatic as well as value contrasts. This contrast exists in muted colors against colors of high intensity; in cool colors (blues and greens) against warm colors (reds and yellows); and in the juxtaposition of complementary (even deliberately discordant) colors. Complementary colors refer to those found opposite each other on most color wheels, and they are also the colors that appear in an afterimage. (When you stare at a red object and suddenly look away, you see a green afterimage.)

While a knowledge of color theory may be helpful in design decisions, it is not essential. As Josef Albers points out in *Interaction of Color*, ''Just as knowledge of acoustics does not make one musical, so no color system by itself can develop one's sensitivity to color . . . no theory of composition by itself leads to the production of music or of art.''

The poster at left by Mikio Oiwake for the 1972 Olympics in Sapporo sets deep black shadows against bright white surfaces, which together set off the centered disk in red.

Contrast of size

There is another form of contrast that can have an even more dynamic effect than value relationships, and that is contrast in scale—the large image against the small image. This type of contrast can be achieved by focusing on the relative size of two or more images on the printed page or on the comparative scale of objects within a given image. A large picture will seem even larger when it is placed near a small image, and in a single picture one object in extreme close-up will contrast dramatically with a distant landscape. For example, when a hand appears on the page larger than life-size and a small figure appears in the background, the visual impact will be intensified.

The importance of size contrast may *seem* obvious, but a great body of mediocre page design is guilty of uniformity of image size or scale. One of the important contributions of the Russian Constructivists was the way that they used contrast in size in their posters to achieve dramatic effect.

Two other forms of contrast are sometimes valuable in the design process and are worth mentioning. One is the contrast of mood, where the same design unit contains two different emotional stimuli: aggressive and passive, cheerful and sad, earnest and humorous. Another form of contrast in layout is the relationship of forms and accents within the design: vertical and horizontal, curved and linear, concave and convex. This contrast can influence our perception of space. Vertical emphasis can make the space seem taller, while horizontal emphasis can make it seem wider. Variations of angles and forms within the space can add an illusion of depth and dimension and even a suggestion of motion or movement.

66

This much-imitated 1935 poster design for a Swiss ski resort by Herbert Matter uses the extreme close-up of the skier's face in contrast to the tiny figure.

Designed by Bob Pelligrini and photographed by Ryszard Horowitz, the page at left for Richton takes full advantage of size contrast. In the design below, which I did for Look magazine, the contrast in size of the Irving Penn photographs was enhanced by using the large object small and the small object bigger than life-size.

LONDON

as seen through the lens of an
artist and pinpointed by that ancient
city's young, space-age poets

THERE ARE AS MANY WAYS to observe London as there are pigeons to make a shambles of Trafalgar Square. It is timeless (ever stood in the Poets' Corner in Westminster Abbey?), and it is of today (here are the miniest skirts!). But it is London's day-by-dayness beneath the "kinky" surface that preoccupies photographer Irving Penn. Tower Bridge, above, a Harley Street surgeon's doorbell, right, a mug of tea set on a step, next page, seem more basic than the Beatles. To extend Penn's vision into words, LOOK drew on the works of some of the young poets of England. John Fairfax, whose anthology of verse *Listen to This* (Longmans, Green & Co., Ltd.) is just out, says: "We try to speak an international language. Some of us are influenced by the poet-scientist-priest Chardin. We are concerned with the space age and what is happening in technical terms. We are thinkers as well as poets. We mix classic with technological terms." His and other voices are heard on the following pages. PATRICIA COFFIN

52 LOOK 5-2-67

PHOTOGRAPHED BY IRVING PENN

The design trilogy

Triforms have played a significant part in the development of modern graphic design. The three basic shapes that were adopted by the Bauhaus and converted into a design philosophy are the square, the triangle, and the circle. This geometric trilogy, which had been explored by Malevich, became the teaching credo at the Bauhaus, and, together with the three primary colors, red, yellow and blue, it provided the foundation for a major group of modern designers.

The acceptance of these forms may seem to be an oversimplification of the design process, but, if they are examined as dynamic forces rather than static shapes, we begin to understand the sophisticated and provocative role they play in modern graphic design.

In 1923, when Paul Klee took over the foundation course at the Bauhàus from Johannes Itten, Klee worked out an explanation of the dynamic potential of these forms that has never been surpassed. After more than fifty years, his ideas continue to provide us with a valid analysis of form. Beginning with the square, he explained how the vertical and horizontal forces act in its creation.

Returning to the geometric postulate that form begins with a dimensionless dot that moves to form a line, Klee then explained how the line gets into a "stress relationship with a parallel line" to form the square until "we can no longer distinguish which line moved, the upper or the lower. The stress relationship therefore is reciprocal."

In the case of the triangle, Klee again traced its creation to what he called "casual forms." He used the plumb line

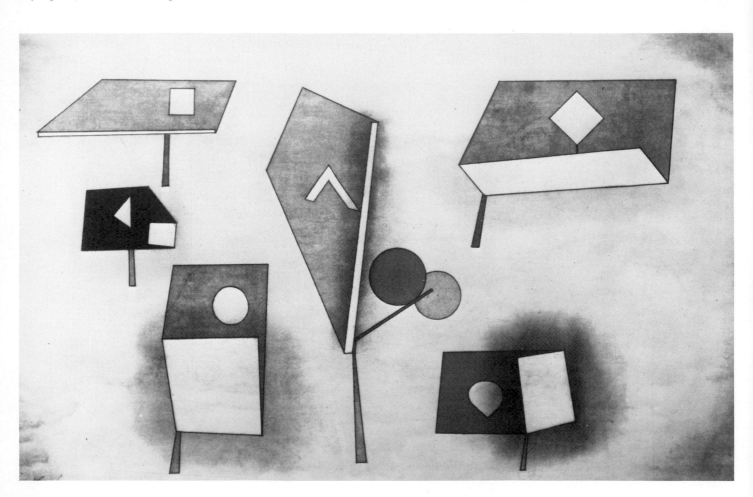

Paul Klee made frequent use of geometric forms in his painting. Here, he uses them to create Six Beings.

that represents the shortest path from the apex to the base and points out that "a triangle came into existence because a

point stressed with a line and following the dictates of eros consummated the relationship." His sketch above demonstrates this dynamic analysis.

When Klee examined the circle, he pointed out that "the question of causality is particularly easy to answer. The circle is dependent on the formation of a center. Its history emanates from the point. This point radiates to all sides and thus moves toward all sides."

To his illustration of the actual, causal, and combined images of the circle, he added these thoughts: "One could say that the pendulum starts to swing, gravity is suddenly cancelled out and centrifugal force takes its place. One could also say that a line finds its center and revolves around it."

Paul Klee also reminded us of the three-

dimensional forms directly related to the square, triangle, and circle: the cube, the pyramid or cone, and the sphere.

Overused and misused or misunderstood, these forms can become clichés, but Klee's interesting view of them points out that the designer's mind must continuously be alert to the intriguing possibilities that lurk behind the most common objects within our perception.

69

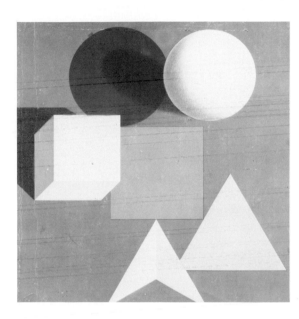

In 1968, Herbert Bayer designed this cover for the fiftieth anniversary Bauhaus exhibition. He featured the primary colors and the principal forms that were such an essential element in Bauhaus design training.

Free form

There were hints of free form in the poster designs and furniture forms of Art Nouveau, but, like so many innovative approaches of twentieth century design, the roots of free form were really in the Dada movement. The traces of these shapes were suggested in the early experiments of Marcel Duchamp, and the ideas were extended by Francis Picabia, Man Ray, and Max Ernst. However, the most impressive suggestion of the design potential of free

form was revealed in Hans Arp's work, dating from about 1915.

Arp, whom Alfred Barr of the Museum of Modern Art once identified as "a one-man laboratory for the discovery of new form," created shapes in painting, construction, and sculpture that became strongly identified with modern art. Writing about his early search for new form, Hans Arp said, "I made my first experiments with free form in 1915. I looked for new constellations of form such as nature never stops producing. I tried to make form grow. I put my trust in the example of seeds, stars, clouds, plants, animals, and finally in my innermost being." His final statement

contains a hint of his later involvement with Surrealism, a movement that continued to create and develop free forms (see page 22).

One of the Surrealist painters whose work is crowded with innovative shapes is Joan Miró, whose freedom from formal conventions and concern with natural objects led him to expand this dimension of form. English artists, like Henry Moore, Barbara Hepworth, and Bernard Meadows, accepted free form as an important element of their art, and, in America, Alexander Calder gave free form movement in his mobiles.

Probably the most important contribution

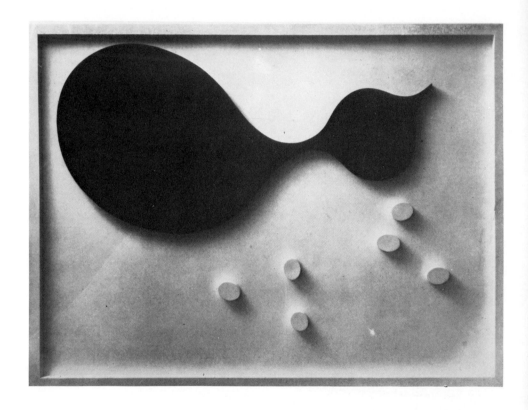

of free form to design is contained in the work of Le Corbusier, the architect whose work transcended all modern movements. His sketches, ground plans, paintings, and sculptures made frequent use of free form in their overall design, and his late architectural designs, particularly the Chapel at Ronchamp, made bold use of this design element.

Free forms were absorbed into graphic design in the French posters of the 1920s and in Art Deco surface designs and graphic forms. They have been used sparingly—but often effectively—by many contemporary graphic designers.

One of the first artists to use free form was Hans Arp, who created this painted wood relief Arrow Cloud *(left) from a private collection in Basel. The design by Bradbury Thompson for the* Production Yearbook *makes effective use of a white shape in a gray background (above). The free-form hand (top) expressed in Le Corbusier's* maquette *is one example of his use of free form in models and art.*

Signs and symbols

In his excellent book *Thoughts on Design*, Paul Rand points out, ''The symbol is the common language between artist and spectator . . . a symbol may be depicted in an abstract shape, a geometric figure, a photograph, an illustration, a letter of the alphabet, or a numeral.''

From the earliest efforts at visual communication, symbols have played an important role. The cross was one of the first symbols of worldwide importance. Aside from its simple—passive-aggressive, male-female, earth-sky—connotations, this symbol also happens to be a symmetrical form. Today, in our materialistic society, we are aware that, in addition to its spiritual and religious meaning, the cross can be read as a mathematical plus sign.

Another common form of symbol is the arrow. In the 1930s, when there was a growing awareness among designers of directional eye movement, the pointing hand or arrow became important devices in typography, achieving balance within the newly popular asymmetrical layouts. More recently, the arrow has taken its proper place as an occasional symbol and directional device in typographic design.

As modern high-speed communication propelled us toward the language barrier, a new need developed to reconsider forms of preverbal visual communication, emphasizing visual ideas that explain functions and operations without the need for letters or words. Multinational corporations with global communications problems have returned to glyphs and pictograms to solve some of their problems.

Paul Rand

a design students' guide to the New York World's Fair compiled for P/M magazine . . . by Laboratory School of Industrial Design

As Paul Rand suggests in Thoughts on Design, *a red circle may be interpreted as a symbol of the sun, Japanese battle flag, stop sign, or ice skating rink, depending on the context in which it is used.*

Paul Rand's cover design (left) uses the symbols of the 1939 World's Fair, the elaborately named trylon (cone) and perisphere (sphere), combined with a cross which in this context becomes a plus sign. In my layout for Look *magazine above, I turned the normally horizontal one-way street sign into a vertical to illustrate New York's upward thrust.*

Dimension: Perspective

From the beginning, artists working on the two-dimensional surface have experimented with ways to suggest distance and depth. The earliest cave drawings placed one animal behind another, and later artists varied the size of the animals in the foreground and the background. In Chinese and Japanese landscape painting, the effect of distance was achieved by subtle gradations of tone, with the near objects being distinguished from those at a distance by the relative darkness of the color.

Our familiarity with photographic images in print—or projected on to the single plane of the movie screen or television tube—sometimes obscures the fact that the dimension we see is an illusion. We have to remind ourselves that perspective as a method of spatial representation hardly existed prior to the fifteenth century. It was then that the horizon line and vanishing point were first used to create the illusion we now take for granted.

A Florentine architect first discovered the mathematical laws of perspective in 1410, and, by the end of that century, Renaissance painters like Masaccio, Uccello, and Leonardo had refined these principles into the currently accepted technique of perspective rendering. The camera obscura, which was invented prior to this time, probably played a role in developing the perspective approach. This forerunner of the modern camera cast an inverted image of a three-dimensional subject on to a two-dimensional surface when light rays passed through a tiny aperture, or lens.

For centuries after its invention, perspective was one of the foundations of Western painting and design. It was only when the Cubists and the artists who followed began to challenge the illusion

El Lissitzky, writing about the three-dimensional illusion, compares it to a pyramid where "the tip lies in our eyes— in front of the object—or we project it to the horizon—behind the object." The last is the usual Western concept of dimensional space, but the designer needs to remind himself that it is not an absolute but an illusion.

of three-dimensional space that designers accepted alternate ways to use the two-dimensional surface. Modern artists suggest depth by using variations of tone and color, and they represent objects from multiple viewpoints, often returning to approaches first used in primitive art.

A knowledge of the guidelines that determine perspective and an awareness of how it works and what it can and cannot do is a valuable asset to the graphic designer, but it is well to remember that perspective remains an illusion and not an absolute image of reality. An examination of the art of children is a good reminder that perspective is not an easily or naturally accepted phenomenon.

Lester Beall's cover design for American Magazine's *promotion uses the photographic perspective of the airplane against the lines converging to infinity to heighten the effect of the design's depth.*

Dimension: Isometric

Another method of arriving at three dimensional illusion is by isometric projection. This oblique method of suggesting depth was originally used by the artists of ancient China, and, at a much later date, it was developed into a system for engineering drawing. The advantage of isometric views over perspective lies in the ability to provide accurate measurements in all directions because the scale is consistent from front to back and does not diminish with distance. It is an approach to form with a proven value to draftsmen and architects, and, from the time of de Stijl, modern designers have been intrigued by the graphic potential of this form of projection.

In a true isometric rendering all horizontal lines are drawn at a 30° angle and these lines remain parallel to one another as they extend toward the horizon rather than converging the way they do in perspective rendering. These parallel lines, which presumably retain their parallel direction to infinity, can create some disturbing distortions and some interesting optical illusions.

For the engineer, there are elaborate rules and regulations governing the use of such projections. But for the graphic designer, who is most inclined to use these angular projections to create an effect, there is very little restriction—except for the use of parallels—and a general freedom to use isometrics as creatively as possible.

Isometric projection is a device that the graphic designer will use only on special occasions where it serves a logical communication objective, or where he wants to free his design from the confines of vertical and horizontal form. One of the areas where isometric views are particularly valuable is in the

The above trademark, designed for Total Financial Services by Gerry Rosentswieg, creates an isometric projection of a common symbol. The advertisement at the right, by the noted Swiss designer Josef Müller-Brockmann, uses isometric form to suggest the dimensional nature of packaging. Both projections are based on the 30° angle.

development of graphs and charts containing statistical information. Here the advantage of accurate measurement and the often useful dimensional effect can help to simplify the presentation of complex information.

This 1924 design of an advertising kiosk to promote the sale of cigarettes was rendered by Herbert Bayer in isometric dimension at the Bauhaus.

Angles and diagonals

For most of the history of the printed page, the right angle has dominated layout. The automatically imposed grid of the printer's em quad and the rigid forms used for press and foundry lock-up of type dictated this rectangular arrangement. The only exception was poster design, where drawing and lettering were rendered directly and often freely on the lithographer's stone.

When the Cubists began pasting and stenciling letterforms on their paintings, they were spared the restrictions of typographic convention. The Futurists and the Dadaists went a step further and assembled their typography by pasting the letters in place for photographic reproduction. The Constructivists extended this approach to more serious applications, and they created some impressive designs based on angles and diagonals.

Though Theo Van Doesburg became a bold champion of angles and diagonals in his painting and finally split up with Mondrian because of differences on this very point, he rarely applied angles to his typographic design. Piet Zwart, a Dutch typographer and contemporary of Van Doesburg, did pioneer some extremely interesting angular layouts, but the Bauhaus designers made only sparing use of this form.

More recently, angular designs have been used occasionally and effectively by Swiss and French poster artists and by American designers like Paul Rand and Lester Beall, and there are signs of a new interest in the angular format in advertising. Müller-Brockmann, the noted Swiss designer, has even worked out a complex grid for graphic display panels based on the 45° angle. Today the designer approaching the printed page is inclined to look on this

Simultaneous Counter Composition, *painted by Theo Van Doesburg in the early 1920s, is an example of his experiments in the adaptation of de Stijl rectilinear patterns to angular form.*

form as a unique, but occasional, change of pace.

The advantages of the angle in page design derive from its contrast with surrounding matter and its attention-getting novelty. Also, graphic ideas that depend on a cross-axis will be easier to read in an angled setting. The disadvantages are its break with established reading patterns, the decreased readability that may result, and the contrived effect that may create reader resistance.

The wartime poster by Jean Carlu is an outstanding example of the forces of tension and equilibrium that angular form can bring to graphic design.

The Modulor: Le Corbusier's design system

Design systems were a natural outgrowth of the modern design movement, which was born in the machine age and evolved through a period of technological and scientific growth. The best known and most interesting of the design modules was the Modulor, created and patented by Le Corbusier in 1946.

Throughout the history of design, there has been a search for systems and

formulas that would assist the designer in his search for solutions to his problems. The ancient Egyptians and Mayans applied mathematics to form in ways that have yet to be fully understood. The classic designers of the Acropolis in Athens made sophisticated use of the golden section in working out the proportions of their architectural designs, and the Japanese made use of modular grids in their painted screens, as well as in their domestic architecture.

Le Corbusier, whose real name is Charles-Edouard Jeanneret, was born in Switzerland in 1887. He moved to Paris in the post-Cubist period, where he became one of the greatest single forces

in the development of twentieth century architecture. In addition to his work in architecture and urban planning, his paintings, murals, and graphics had a significant influence on the design of two-dimensional surfaces.

One of his contributions that is still being assimilated into the fabric of modern form was the Modulor. This design system took the golden section one step forward by linking it to the scale and proportions of the human figure. Le Corbusier based his system on three main points in the anatomy of a six-foot man; the solar plexus, the top of the head, and the tip of the extended fingers of a raised hand. These points yield a

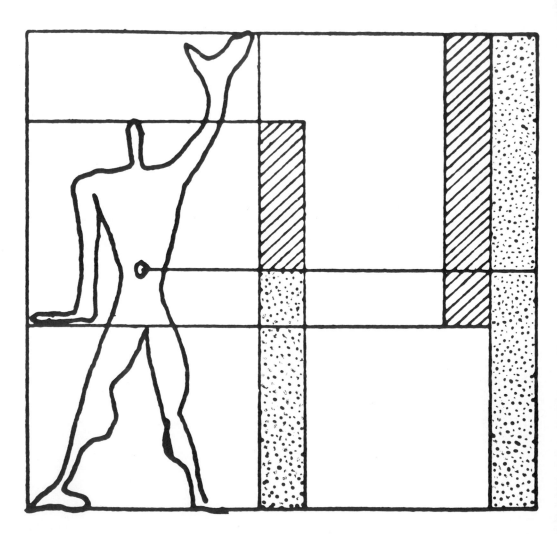

mean and extreme ratio (golden mean), which Corbusier translated into an infinite series of mathematical proportions.

The Modulor was introduced at the end of World War II, and, though its principal application was to architecture, it can be applied to the two-dimensional plane. Before Le Corbusier patented the Modulor, he asked Dr. Albert Einstein for his opinion of the system. Einstein wrote that in his view the Modulor qualified as ''a range of dimensions which makes the bad difficult and the good easy.''

The Modulor has contributed to contemporary graphic design in two important ways. First, the system itself has a direct application to page design—though it is so complicated and its variations are so inexhaustible that its applications have been severely limited. Second, and this is probably of greater importance, because of the way in which Le Corbusier's Modulor can develop asymmetrical designs out of a symmetrical mean, it inspired graphic designers to create grids and design systems for the printed page.

 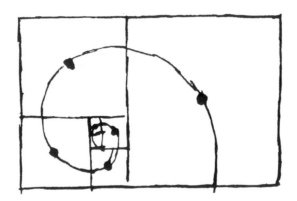

Le Corbusier, one of the foremost designers of the twentieth century, was fascinated by the analysis of form and the division of space. He worked out a system of design called the Modulor, illustrated in his drawing at left, which is based on three main points of anatomy—the solar plexus, the top of the head, and the tip of an upraised hand. These produce a measurable mean and extreme ratio (golden mean). Le Corbusier was also aware that a design often begins within a space and develops outward. His sketches compare that action, in his design for an expanding museum, to the form of a snail.

Grids and systems

Unlike the Modulor of Le Corbusier, a grid is created as a planned solution to a given problem and is not based on a predetermined set of proportions. A designer's grid organizes specific content in relation to the precise space it will occupy. When the grid works, it will permit the designer to create many different layouts containing a variety of elements within the framework of the grid. When used in the design of a publication, an advertising campaign, or a series, it will give a sense of sequential continuity even when there is considerable variation in the content of each unit.

The grid concept has been applied to a broad variety of design problems: books, magazines, catalogues, annual reports, newspapers, brochures, sign systems, and advertising campaigns. In some ways, the preprinted sheets that indicate the margins and columns of magazines and newspapers can be considered to be grids, but the creative key to a designer's grid is the carefully planned relationship between the vertical and horizontal divisions and how these relate to the overall design.

In determining the best proportions of a grid, the designer may depend entirely on his intuitive judgement, or he may base his system on established rules governing the division of space, such options including the square, double square, and golden section. The measurement of the outer perimeter of the page is often expressed in inches or millimeters, but the inner dimensions of the grid are usually expressed in typographic measurement. Because the width of type columns is generally specified in picas (six picas equal one inch) and half-picas, the vertical divisions are measured in picas. The horizontal divisions, on the other hand, are most frequently measured in

increments that equal the height of a single line of type together with the space between the lines. A ten-point type (12 points equal one pica) with one point of space between the lines would create an increment of 11 points.

The grid has many champions, but it also has many detractors. When it is used with skill and sensitivity, it can produce handsome and effective layouts. When it is applied to multiple units, it can generate a sense of continuity and flow that has a distinctive, unifying value. However, in the hands of a less skillful designer, the grid can become a straitjacket that produces dull layouts and a rigid format.

In the words of Swiss designer Josef Müller-Brockmann, ''the grid makes it possible to bring together all of the elements of design—typography, photography, and drawings—into harmony with each other. The grid process is a means of bringing order into design.'' Le Corbusier, in his own appraisal of the Modulor, adds this final note of caution: ''I still reserve the right at any time to doubt the solutions furnished by the Modulor, keeping intact my freedom, which must depend on my feelings rather than my reason.''

The grid provides a designer with his own system for organizing the typographic and visual elements of the layout while relating each individual spread to the overall format. The 12-unit grid at the left was used by Willy Fleckhaus on Twen *magazine (above) and was later adapted for* Look *magazine by Will Hopkins, as demonstrated in the layout (left). This grid, prepared for a large page size, can be effectively used for a two, three, four, or even six-column makeup. It creates an almost endless group of design options.*

Summary: Filling the void

No study of form in graphic design can be complete without an analysis of the space it occupies. This is where design begins, and where the action takes place. Most experienced designers have conditioned themselves to carry a blank white rectangle in their minds, constantly ready to accept, assess, and possibly reject the ideas that their minds conjure up to solve design problems.

Reviewing the careful and separate treatment given here to the varied and sometimes complex factors of form, the reader might be led to believe that the design process is a logical, step-by-step procedure. Nothing could be further from the truth. In the hands of a skilled designer, the process is complete and continuous; intuitive feeling, a sense of form, and accumulated experience are blended into a single act. Remember, though, that this does not exclude the importance of trial and error in the search for an optimum solution.

After the designer has arrived at a layout idea in his mind, he transfers his thoughts, often simultaneously, to a quick thumbnail (miniature) sketch. At this point, the idea undergoes another stage of assessment and revision or modification. Some ideas are rejected before they are expressed on paper, and others end up crowding a number of wastebaskets. On rare occasions, the designer's first idea finds its ultimate expression in the first sketch, and a photographic enlargement of it will be a crude facsimile of the resulting proof.

The principles of form discussed on the preceding pages can be applied to the blank space of an imaginary rectangle, which can accommodate the symmetrical arrangement of material on a central axis or the more complex asymmetrical groupings of elements with

Bradbury Thompson's design for a publication of the Westvaco Corporation is an interesting adaptation of symmetrical form. The visual elements are arranged around a central axis that can be viewed from different directions.

equal ease. The space is large enough for a newspaper page or small enough for a postage stamp. It can represent a page in its vertical format, or, turned on its side, it is suitable for a two-page spread or even a 24-sheet poster.

The space of the imaginary rectangle also can be divided into an ordered grid based on the golden mean. Within it, the designer can develop a module without regard for formulas and with only his eye to guide him in setting the proportion. If he wants to avoid these restrictions, he can use the space with total freedom. In any event, a sense of balance will be a paramount concern. In a symmetrical layout, with its central axis that divides the space evenly, this will not be difficult to achieve. But when he opts for the asymmetrical form, the designer will do it with a knowledge that, as in walking a tightrope, continuous and perfect balance will not be much more interesting than someone walking on a concrete sidewalk.

The minute a mark is placed on the white space of the rectangle, the forces of value relationship, contrast, and dimensional depth are called into play. The tone value makes an important contribution to the depth illusion because the eye generally accepts the dark mark as nearer than the white field it occupies. And one form of contrast, the

This design by Lester Beall for the Production Yearbook *in 1950 creates a rhythmic, free-flowing pattern.*

relation of the dark mark to the light background, has been introduced.

In adding a second mark to the rectangle, particularly if that mark is larger than the first, another aspect of contrast arises. The large and small marks create a contrast in size that can influence visual attention and set up another element in depth perception, as the large mark seems to be nearer than the small one. At this point, the designer may want to alter the size of the larger mark to intensify the contrast.

If we introduce a line into the space, other influences come into play. Placed vertically, this linear element will divide the space without disturbing the two-dimensional quality. When the vertical line is crossed by a horizontal line, we begin to feel the forces of tension and contrast that are inherent in the aggressive (vertical) and passive (horizontal) symbolism produced by this linear combination. It is also interesting to combine these lines in a symmetrical form, with its resulting cross, and in an asymmetrical form, with its off-center Mondrian-like organization of space.

Aside from the suggestion of a distant horizon line implied by the horizontal line, this arrangement of two lines remains rather firmly locked in the two-dimensional plane. If, however, instead of the vertical and horizontal, we introduce a line at an angle to the rectangle that defines the space, there will be a suggestion of depth and perspective. One end of the line may seem to be nearer than the other, but which is which? Without other lines, it is difficult to determine which way the line moves. A second line will help, and a series of lines aimed toward a vanishing point will give a fairly clear representation of the perspective illusion, with a precise indication of the foreground and background.

By using shapes from the geometric trilogy—squares, triangles, and circles—instead of marks or lines, we introduce

86

The first mark on a blank piece of paper begins the design process. A dark mark will not only set up contrast with the light area, but will seem to move forward in the space. As other elements are added, more complex relationships develop with resulting shifts in symmetry, equilibrium, value, and dimension.

other implications of design more concerned with forms and symbols. By taking three of any one of these shapes in varying sizes and positioning them within the framework of the rectangle, we can produce an almost endless series of abstract design solutions. When we change the values of the shapes to a range from gray to black, or if they appear in the primary colors, we open up a new range of design solutions that will cover almost every aspect of form covered in this section.

On occasion, highly successful layouts for the printed page will seem to violate all of these principles, but the skilled designer is familiar with the rules of form and order, and is aware of the pitfalls that clutter the path of contrived and self-indulgent solutions. Up to now, this entire survey of form has neglected what many would consider the most important ingredient of the design problem— *content*. The following section will be devoted to this aspect of layout.

This simple demonstration of the effect of mass on an area uses three elements and arranges them first in a symmetrical and then in an asymmetrical layout (right). These are only two of many possible solutions to the same design exercise.

content

Content: Word and image

In attempting to simplify the understanding of the design process, this book may seem to place the cart before the horse in concentrating on style and form before content. The areas covered so far are of great importance to the graphic designer, but, because he does not work in a vacuum, these principles of design would be meaningless without an understanding of the purpose he serves in the communication of ideas.

When the modern movement first took shape, the communication demands on the designer were often fairly obvious. It was enough to establish the name and identification of the product or service and imply the satisfaction derived from its use. In more complex situations, the designer was only expected to organize the information he was given in a reasonably logical and readable way on the printed page.

Throughout this century, there has been first a gradual and then an accelerated movement of communication patterns until today the public is virtually bombarded by printed and projected images until most of them become blurred and meaningless. This burden of visual ideas places new demands on the designer for more knowledge and for a greater involvement in the planning and problem-solving aspects of communication. Whether he likes it or not, the contemporary art director must be at ease with editorial thinking, advertising objectives, market strategy, human response, and social responsibility—if his layouts are to move from the egocentric boundaries of the drawing board to the excitement of the printed page.

This section will renew the search for the creative solution with a special emphasis on the visual and verbal

Today's graphic designer is involved in a complex process of studying and evaluating many elements before he is able to weld words and images into the final layout.

elements that form the primary content of layout. After an introduction to the design synthesis and the creative concept, this book will take a close look at words and typography, photography, photograms, photomontage, drawn illustrations, and pure graphic images.

In the late 1920s and 1930s, when the modern design movement was in its first thrust and the communication revolution in the popular press was beginning to take form, design began to occupy a dominant position on the printed page. By the 1940s, there was less emphasis on the plastic form of the page itself and more on the visual content. This was the period in which the great illustrators dominated editorial pages and advertising. By the end of World War II in the mid-1940s, photography—inspired by a decade of leadership by the picture magazines *Life, Look*, and *Picture Post*— began to take the spotlight away from illustration. Though the photographic emphasis continued until the end of the 1960s, a new concentration on word ideas and word images began to take form in the 1950s, and this emphasis continued into the 1970s. The resulting search for verbal approaches and provocative headlines led to the formation of art and copy teams dedicated to the pursuit of the creative concept. Although these gyrations of emphasis only reinforce the fact that the most constant element in design is change, they do not diminish the importance of finding the right solution to a design problem, regardless of trends.

In the 1940s, when the advertisement at right was produced by Ashley Havinden for Simpson Ltd. in London, design was the dominant element.

92

This 1955 design by Saul Bass marked
the first time modern graphic design was
applied to both the printed promotion
and the title animation of a major
Hollywood motion picture.

The design synthesis

By now, it should be clear that the process of design and layout is a good deal more than the arrangement of elements on the printed page. A design can be considered successful only when it is a synthesis of all available information translated into words and images and projected in a dynamic form. Its success further depends on the designer's ability to blend the mainstream of visual communications with his training, accumulated experience, and innate talent.

The process we call creativity has been subjected to intensive psychological study in recent years, but few facts have emerged that can help the designer understand this intuitive act. At the root of the process is a struggle between opposing forces, as subconscious ideas come up against intellectual analysis. The tensions that arise from this struggle—between the conventional and unconventional, the logical and the primitive—constitute a complex asymmetric form in which equilibrium can lead to a solution of great simplicity. We also know that someone who is creative may pay more attention to inner thought and vague feelings than a pragmatic individual.

One aspect of creativity that defies study and analysis is its peculiar cyclical nature. Most designers will agree that, while there are times when creative ideas surface easily and design problems will almost "solve themselves," there are other times when no amount of effort will produce more than a routine solution to the simplest problem. As a major part of the creative process is subconscious, this apparent blockage cannot be overcome by any rational or logical approach, and each designer will have to face these periods in his own way. Sometimes getting away from the

The concept or idea occupies the central position in the design synthesis. Supported by the information supplied by research, it is influenced by an understanding of the conditions under which the message will be received, plus an awareness of its continuity with other related material. These elements serve as a foundation on which the words and images can be combined into a successful layout.

problem and concentrating on something completely different will help. Sometimes exposure to unrelated design objects, such as abstract painting, will gradually set the creative force in motion. Sometimes mere scribbles and scrawls will suggest images and ideas. Most often time seems to play the key role in overcoming subconscious resistance.

When the designer lets his intuitive notions *dominate* the creative process, he will gravitate toward self-indulgent solutions that may defeat the communicating purpose of the problem. On the other hand, if his approach is purely pragmatic, the resulting design will lack the spark of originality and usually end up looking imitative or dull. For most designers, creativity means a constant struggle for equilibrium between self-expression and the externally imposed, rational consideration of the communication problem.

The creative concept

Perhaps too much has already been written about the *concept approach* to advertising, but it would be a serious omission in a book on page design to ignore its importance as a highly successful way of solving design problems in the persuasive area of graphic design.

Concept, which in its simplest form is synonymous with idea, has taken on a much broader connotation in advertising. On the one hand, it suggests analysis and comprehension of the product and the problem, the relation of product to sales objective and market, and the development of a headline and a combined word and picture approach that is both persuasive and believable. But *concept*, as a term in advertising, suggests another and more important meaning to the designer. It suggests the teaming up of the writer and designer to solve a problem through their combined effort.

For many years, advertising design followed a procedure where the copy was written first and the art director—like a custom tailor—worked out his design solution to fit. As modern designers entered the field with ideas of their own, they began to exercise a strong influence on advertising ideas. In the 1940s, designers like Paul Rand and Lester Beall and art directors like William Golden at CBS and Charles Coiner at N.W. Ayer were beginning to tip the balance away from purely verbal concepts.

The man most frequently identified with the concept and team approach to advertising is William Bernbach. Though he is not a designer but a writer, he is noted for his work with many important art directors including Paul Rand, Erik Nitsche, Bob Gage, Helmut Krone, and George Lois, and with a whole

96

The original concept for the advertising campaign for Volkswagen was developed by Robert Levenson, a top writer and now Vice Chairman of Doyle Dane Bernbach, working with art director Helmut Krone. The classic ''Think Small'' advertisement appeared in 1959, and, though it failed to receive a gold medal in the Annual Art Directors Exhibition, scores of its descendants went on to dominate the shows. By the time the VW advertisement on the facing page appeared over a decade later, the name Volkswagen was so well-known that only a trademark was needed for identification of the advertiser.

generation of art directors who came under his influence. By the time he joined with Ned Doyle and Mac Dane to form the Doyle Dane Bernbach Agency in 1947, Bernbach's idea of a coordinated art and copy approach to advertising was well developed.

Because Bill Bernbach believes that product understanding and selling ideas are more important than technique, some design critics have complained of the agency's failure to use all of the tools of modern graphics. However, Doyle Dane Bernbach's standard of quality has been high, and for years their advertisements dominated the Annual Exhibitions of the Art Directors Club.

Perhaps no single advertising effort better symbolizes the concept approach to advertising and page design than their campaign for Volkswagen. Detroit laughed when this car first appeared on American highways, but somehow the creative teams at Doyle Dane Bernbach managed to uncover an amazing number of virtues to use in their advertisements. They were even able to make an advantage out of its ugliness through inverse snobbery and the suggestion that plainness was related to dependability.

It's ugly, but it gets you there.

Typography: The visual language

Typography has always been a primary element of the printed page. Today, under the increasing pressure of visual saturation and the resulting emphasis on word concepts, typography has an even higher priority in the designer's world—but there is still a surprising number of graphic designers who look on type as a necessary evil and there are too many layouts where type was obviously an afterthought.

There is no justification for the designer who considers words as something to be weighted, specified, and measured without any regard for their message or meaning. Words are communication. As one modern prophet points out, it may be true as Confucius said that a picture is worth a thousand words, but it took words to say so. The contemporary designer is well-advised not only to read the words that go into his layout, but also to understand them. He may even contribute to word content through ideas and suggestions of his own.

In the 1950s, a re-emphasis on word content began to influence page design, and, as so often happens, a major

technological change began to affect the use of letters and words. Although photographic lettering had entered the design scene a decade earlier, its primary purpose was to augment or replace hand-lettered forms. By the 1950s, photographic lettering became a serious competitor to hand-set display type, and, with the help of the computer, it began to make inroads into machine typesetting as well. Photographic methods made the revival of old typefaces simple and economical, and it made the design of new typefaces easy.

Using traditional means of drawing and punch-cutting, the design of a new alphabet usually took many months of

This Park Davis & Company headline designed by Richard Bergeron is an excellent example of combined visual and typographic appeals.

effort by an experienced type designer, but today any designer with fair talent can produce an alphabet through photographic means in a matter of days or even hours. New photographic type machines have given designers a freedom to experiment in typography that was nonexistent in the early days of the modern design movement. This freedom goes far beyond the wider choice of type styles. Now the designer can overlap and interlock letters without cutting. He can vary the weight and slant of the letters. He even has a new range of options within a given type family—alternate characters, ligatures (joined letters), special symbols, devices, and ornaments.

Aided by the computer, the designer has many opportunities to explore new methods of text composition. He can control the space between letters as well as the distance between words and the space between lines—he can even set lines so close together that the effect is comparable to setting a 10 point type size on a 9 point body in normal linotype composition.

Still another innovation that is influencing typographic design today is the introduction of transfer sheets that permit the designer to adhere precise type letters onto his layout. These sheets not only offer a wide choice of type styles and type sizes, but include all manner of

This classic design promoting a Swiss newspaper uses an imaginative transposition—of the N for National into the Z for Zeitung—and a diagonal format to produce unity.

decorative devices and textural surfaces that can be incorporated into layouts. Thus a designer can get by with less lettering and rendering skill than he could have a few years ago—but he stands in some danger of being trapped into a comfortable conformity.

These dramatic changes in the techniques of typesetting and typographic design have been a mixed blessing. Like a small boy let loose in a candy shop, the designer is constantly drawn toward the excesses that so often destroy the simplicity, directness, and originality of his layouts. In a strange way, the ease that these devices bring to page layout requires greater skill and increased self-discipline. The designer must understand the often subtle differences between the systems he works with, and he must be strong enough to resist the temptations and avoid the pitfalls of too many options and opportunities.

It is beyond the purpose of this book to give a detailed study of typography. Only those points that have a critical bearing on the design of the printed page are emphasized here. The glossary that follows will clarify the points on typography covered on these pages.

Ascender: The part of a lowercase letter that extends upward to match the height of a capital letter.

Cold type: Type set by photographic means or prepared on a typewriterlike machine.

Descenders: The part of a lowercase letter that extends below the baseline of the letters.

Body: The overall area of a block of type.

Face: The part of a letter that is reproduced on the printing surface.

Flush left: Type set with an even margin at the left, but with an uneven right-hand

100

Herb Lubalin is a designer who uses typography as a plastic element with great imagination and skill, as in this headline for Ladies' Home Journal.

The typography for New York's Urban Coalition, designed by Marvin Lefkowitz of Young and Rubicam, shows the effectiveness of blunt typography, which is as direct as the truth it invites you to face. The use of the period adds important emphasis.

margin. (In England, called range left.)

Font: The complete set of capital and lowercase letters, plus numbers, punctuation marks, and spaces of a given size.

Hot type: Type set by individual letters or lines of cast metal. Methods include foundry (hand-set), Linotype or Intertype, and Monotype.

Justified: Type set in lines of equal length.

Line space: The depth of a line of type, usually including the space between the lines. In hot typesetting, the space

between the lines is called leading.

Modern: The designation of a type style that has crisp, thin line serifs without curved connections between the strokes. These typefaces, such as Bodoni, Didot, and Walbaum, also have a clear distinction between the thin and wide strokes.

Old style: A style of type, such as Caslon, Garamond, and Times Roman, that follows the models of the early Roman letters first perfected by Venetian type designers. The serifs flow out of the strokes in a simple, graceful curve.

Point: A basic U.S. and English unit in

This advertisement, designed by George Lois for Wolfschmidt Vodka, takes its theme from the comic strip and gives it an exciting typographic refinement.

printing used to identify type size (height), line spacing, and so on. There are approximately 72 points to an inch.

Pica: A type measurement normally used for the measurement of line widths and margins. One pica equals 12 points and there are approximately 6 picas to an inch.

Stroke: The stem and curves that give letters their basic form.

Structural: One way of describing the type style that includes the letters not based on brush or pen strokes. This category includes all the sans serif letters, as well as those with block or square serifs.

Transitional: The type styles, such as Baskerville, Bell, and Modern, that fall between old style and modern, with minimal curves connecting the serifs to the strokes.

Typeface: The printing surface of a type—the style of letter it reproduces.

Weight: The boldness of a typeface, determined by the thickness of its strokes.

X-height: The measurement of the height of a lowercase letter without including ascenders or descenders. A 10 point type with a large x-height will be larger and more readable, but it will allow for fewer characters per line and will usually call for additional space between lines.

102

How do you measure a last laugh? In this CBS advertisement, art directed by Lou Dorfsman, carefully articulated typography creates visual excitement.

The typographic interplay of positive spaces (2) and negative spaces (3) makes this typography—designed by Brownjohn, Chermayeff, and Geismar— an exciting demonstration of the potential of thoughtful typography.

1ne
2wo
3hree
4our
5ive
6ix
7even
8ight
9ine
10n
11even

Typography: Serifs and simplicity

The classic revival of typography was based on the old style letters developed in the fifteenth century, particularly the alphabet introduced by Nicolas Jenson in Venice. The capitals of this alphabet were based on the still earlier model inscribed on the Column of Trajan in Rome at the beginning of the second century. These letters—which we still refer to as Roman—had serifs, or short cross marks, at the beginnings and ends of most letter strokes.

There is still some argument about the origin of serifs. Were they the result of brushstrokes used to draw the letters on the marble before cutting, or were they created by the chisel as a starting or finishing mark for the cut letters? There is even more argument about the continuing value and necessity of these typographic appendages, and it is this question that concerns the contemporary graphic designer.

More than five hundred years before the Column of Trajan was completed, the Greek designers were inscribing equally handsome letters without any serifs at all. Through the nineteenth century, Roman letters with serifs dominated the printed page, but, as early as 1816, a sans serif typeface appeared in the specimen book of the Caslon typefoundry. This typeface was only one of several structural letterforms, including square serif styles, that were to be designed for publicity and poster use in the nineteenth century.

In the 1920s, when modern typography was in its critical development stage, sans serif letters came into ascendency. El Lissitzky, Jan Tschichold, and the designers of the de Stijl and the Bauhaus opted for the simplicity and purity of the sans serif form, but they were forced to use typefaces designed in another time for another purpose. The one modern sans serif type in existence was the one

Long before the Romans introduced letters inscribed with serifed ends, the ancient Greeks had created clear, geometrically formed letters without serifs, as revealed in this marble inscription from 500 B.C. in Athens.

designed for the London Underground by Edward Johnston in 1916, and it was not available for general use.

Before the end of the 1920s, two important new faces appeared. One was Futura by Paul Renner, and the other was Gill Sans Serif by Eric Gill. But the typeface that most nearly fulfills the ideal of the modern typographers was gradually developed and not finally completed until the late 1960s, when the Haas Typefoundry in Switzerland introduced Helvetica. This is the sans serif typeface most designers would pick if they had to select only one, although there are perhaps a dozen typefaces so much like it that they could be distinguished only by experts.

While it is possible to produce a solution to any type problem by using Helvetica alone, many designers feel that there is sufficient need for typographic variety to call for the use of many different typefaces. The comfortable, classic character of an old style letter with its graceful serifs; the crispness of a modern type with its thin, line accents; and the brutal character of an Egyptian style with its block serifs all represent added potential for excitement.

This cover, from a recent issue of the French art magazine L'Oeil, *combines the elegance of a serifed face with the structural quality of the sans-serif letter in dimensional form.*

Typography: Style and legibility

The Art Nouveau and Art Deco periods (see pages 16 and 32) created special type styles to reflect the character of the periods. But by the time the modern movement took its final graphic form under de Stijl and the Bauhaus, typographic style had moved almost exclusively to sans serif. Since then, the strong emphasis on structural typefaces has continued—although the sans serif dominance has been stronger in Switzerland, Germany, and Italy than in France, England, and America.

The search for style in letterforms reached its zenith in the 1970s. Aided by the new techniques for type transfer, a new breed of typeface designers emerged. Their sources included Art Nouveau, Art Deco, and nineteenth century wood types, as well as classic and modern letterforms. While the product of this revolution of convenience added some innovative forms to typography, much of it was merely fashionable and often not very well designed. What it all seemed to prove was that when eccentric, poorly designed letters are used as a substitute for creative ideas, the results are usually disastrous.

Perhaps too much thought has been given to the appropriateness of a typeface to the message. While there is valid ground for such considerations, qualities like age and tradition are not necessarily well served by old styles; nor is it essential to use a bold, structural letter simply because we are dealing with machinery. There is no law that prescribes a letter with a crisp serif for fashion or a flowing script letter for a perfume. A classic example of the successful typographic use of what seems like an inappropriate typeface is the label for Chanel No. 5, with its sans

Paul Rand used a condensed sans-serif type in this announcement cover, and the design gains distinction from the use of a carefully placed figure 8 to both identify the conference as the eighth in the series and to serve as the letter g.

serif letters that have been the hallmark of elegance for nearly fifty years. Special values can best be served by a total design concept that avoids imitation and suggests the values it serves in an original and creative way.

Legibility is another area where the designer can be misled by what seems like an obvious dictate in type selection and design. There can be no question about the readability of the message, but legibility and readability are not quite the same—a dull and uninteresting presentation in a highly legible typeface will not be widely read. There have been many studies of comparative legibility, and each study seems to surface with slightly different conclusions. For the designer, the best solution is to use his material in such a way that it arouses interest and invites reading.

Consider the egg. Dansk did. One of nature's most satisfying and useful forms, it signifies the beginning of things. The beginning of Dansk things was 10 years ago, when this first Fjord spoon was hand-forged. Its success egged us on to create a number of other fine objects. Tawny teakwood bowls. A candlestick crowned with twelve thin tapers. Dusky Flamestone cups. An enamelled casserole as bright as a sunflower. And linens with rainbows in their warp and woof. Today there are 493 Dansk designs. Every one made for daily use. And not an everyday piece in the lot. They all appear in a new 96-page book, a book with the good form to be absolutely free. Write Dansk Designs Ltd, Dept. O, Mount Kisco, N.Y.

The typography of Lou Dorfsman's design for Dansk presents a simple and readable handling that embraces the illustration at left. Any designer who thinks that only flowery letters are appropriate for perfumery should study the classic Chanel No. 5 label.

Photography: Camera and image

Of all the related visual disciplines, photography is probably the one of greatest importance to the graphic designer. Throughout the process of layout and page design, photographs and photomechanical techniques are vital factors in the success of the product.

The history of photography is well-documented, beginning with the first dim photographic image produced by Joseph Niépce in 1816 with a process later improved by Louis Daguerre in what was to become known as the daguerreotype. Fox-Talbot's experiments in England with photographic chemistry and paper negatives—which made quantity prints possible—are also well-known. There is one development of photography that is not as well-documented but is of critical importance to page design—the development of the photographic enlarger. This instrument did not emerge in any practical form until the beginning of the twentieth century, and before then—without an enlarger—photographers had to accept the image size and shape that slowly developed on their plates. The only way they could modify the image was to cut it into still smaller segments. The enlarger not only freed the photographer from the burden of lugging bulky cameras into the field, but gave the designer the opportunity to use photographic images creatively in unlimited shapes and sizes. Enlarging permitted the designer to crop pictures into tighter and often more dramatic compositions (a custom not always approved of by the photographer). It became possible to combine images in controlled scale by superimposition and collage, and to control (and even alter) the picture in the darkroom. El Lissitzky was one of the first of the modern designers to take advantage of this flexibility, and he was the first to use

Many of the effects considered modern were arrived at in the early days of photography. Sometimes they were the result of planning and sometimes of accident, as in the lens distortion of this 1911 photograph by Jacques Lartigue.

extreme photographic blowups in exhibition design.

Another footnote to photographic history with a particular bearing on graphic design is the development of photo-engraving. Though Niépce had discovered the principle of this kind of reproduction thirteen years before he made his first photographic print, and Fox-Talbot had developed the theory of halftone reproduction in the 1850s, the practical application of this process did not surface until the end of the nineteenth century—and its final development paralleled the growth of the modern design movement in the twentieth century.

Because a layout does not truly exist until it is reproduced on the printed page, and because its final quality is judged by the printed result, the designer is very much involved in the reproduction process. He needs to be a critical judge of the reproduction potential of the proofs and images that he furnishes to his platemaker, and he must learn to judge the performance of his suppliers by understanding the proofs and printouts he receives in advance of final printing. In many cases, he will be spared the increasingly complicated production details by the specialists in the production department. However, the best of technicians cannot improve on the quality of the material that the

This imaginative use of the photographic sequence was created by Edward Steichen for Dr. Agha, art director of Vanity Fair *magazine, in 1931. The sequence combines an effective summary of Chaplin's art with a carefully planned composition.*

designer supplies them with or on the clarity of his instructions.

Designing with photographs calls for a knowledge of the photographic process, an awareness of the picture content in relation to the communication objective, and a keen eye that can comprehend the design, value, and contrast within the photograph. Where more than one image is involved, the designer will also have to measure their collective force—how the photographs work together, how they relate in value, and how their forms will relate when positioned in the layout.

Photographs for the printed page come into being in one of the following ways: they are taken on specific assignment to match or approximate the predetermined guide of a sketched or rendered layout; they are taken on a general assignment to create a solution to the problem without a preconceived layout or visual to guide the photographer; or they are taken from existing sources, and the layout is designed to take advantage of the values already present in the photographs.

Working with photographers is one of the most important aspects of the designer's work. The art director who considers the photographer as a mere servant—whose only purpose is to carry out the designer's directive or click the shutter on an already composed picture—will probably miss the creative rewards of this collaborative effort. The photographer is a trained visual communicator, and a wise designer will take full advantage of his contribution.

Sometimes the problem of designing with photographs will involve the selection of one or two of them from several hundred or even thousands of exposures. Like many design functions, this selection is largely based on an intuitive response that is difficult to explain. The importance of the first reaction in this process cannot be overemphasized. Those images that

110

The design of multiple photographic elements is expertly handled in this layout by Chuck Bua for Clairol with photographs by Richard Avedon. The spread makes effective use of size contrast and white space.

arrest our vision in a casual glance at the contact sheets are probably the ones that will attract the reader's attention on the printed page. These images will have to stand up to the tests of relevance to the communication problem, relation to the overall design and believability. This last item is not as obvious as it sounds, and it is not necessarily related directly to either reality or truth. Sometimes a photograph that is a precise record of an event will look false and contrived, while another photograph with a less real background will seem to be more convincing. While the designer should not be involved in misleading the reader, he must be aware of reader reaction and reader response to his layouts.

The designer's perception and understanding of visual images can be strengthened by a constant analysis of those visual experiences that are available to him. By studying everything he sees as a picture possibility and by examining those photographs of exceptional quality that make him turn the page back for another look, he will develop the curiosity and discernment so essential to the creation or selection of powerful images.

This dramatic 1958 poster by Josef Müller-Brockmann, with photography by Ernst Heiniger, combines contrast of size and a powerful angle of action.

Photographic effects

In the years between Niépce's historic first exposure and the turn of the century, nearly every special effect that could be achieved had been tried and printed. Edward Muybridge and Thomas Eakins had stopped action and superimposed moving figures in pictures that forecast Duchamp's *Nude Descending a Staircase*, painted nearly thirty years later. Henry Robinson and Oscar Rejlander had combined images by montage and superimposition to create the photographic equivalent of romantic nineteenth century paintings. Mathew Brady and his staff had wrestled their cumbersome equipment around the battlefields of the Civil War to set the course for future generations of photojournalists.

The increased use of the photographic enlarger and the development of sophisticated darkroom techniques in the period after World War I led to other photographic effects that took place outside the camera. This approach is generally referred to as lensless photography, and it is not surprising to learn that among the first to experiment with it were the Dadaists. Arp was involved in some of the earliest experiments, but the true pioneers of lensless photography were Christian Shad and Man Ray, who developed the photogram which reveals the image of objects placed directly on photo-sensitized paper and exposed through controlled illumination. In the early 1920s, El Lissitzky first used the photogram in the design of the printed page, and, in the decade that followed, Maholy-Nagy and Gyorgy Kepes extended its application to design.

When color photography joined black and white in the 1930s as a readily available photographic method, other variations in technique were introduced,

The photograms by Man Ray, which he called Rayographs, *together with the earlier experiments by Christian Shad set a style in lensless photography that had a major effect on the design layout.*

112

including infrared film and x-ray. Added to the technical effects already developed in black and white, such as superimposition, double exposure, solarization, and lensless photography, these new options gave the photographer and designer an extensive—though sometimes confusing and often expensive—series of possibilities.

The following list includes some of the effects that can be achieved outside of the camera—but it does not include the wide range of choices opened up by modern lens technology. Today cameras can be equipped with hundreds of different lenses from extreme telephoto to the ultimate wide-angle of the Wide-lux and fisheye lenses providing a photographic field of up to 360°. The photographer's gadget bag may include macro and micro lenses, as well as zoom lenses that can be manipulated to create unusual effects.

Superimposition: Two or more overlapping images created by double-exposure on the film negative or by the combined printing of more than one negative to create a single print. In color, a similar effect is possible by sandwiching two transparencies together.

Montage: Combining two or more

Gyorgy Kepes' 1937 design for a cover of Cahiers d'Art *combined a photogram and torn edges to convey the avant-garde character of the content.*

images by printing them separately and mounting them into a single composition.

Photogram: A purely lensless photographic technique in which objects are placed on photosensitized paper and exposed by the manipulation of light sources, such as the flame of a match, a small flashlight, or general illumination. When the print is developed, the background turns black and the objects and the resulting shadows loom as light tones.

Solarization: A method of changing the texture of the printed surface by a momentary second exposure of light.

Adaptations of this method are used to turn halftone images into line values, with the tones reduced to a texture in pure black and white.

Chimmigramme: A fairly recent, complicated process developed by Pierre Cordièrre, a Belgian abstract painter. In this process, chemicals are applied directly to photosensitized paper to create controlled accidental effects similar in approach to the action paintings of Jackson Pollock.

These are the principal photographic effects available to the contemporary designer, but new scientific processes are constantly extending the horizons of photographic technology in both black and white and color. The introduction of stroboscopic light sources expanded the dimension of multiple image photography; the exploration of invisible rays that can expose the emulsion of photographic paper; and the invention of holography, a process that produces three-dimensional images through the laser beam without the use of conventional lenses, are all developments that will continue to influence photographic images.

114

Paul Rand's photogram from the cover of his book Thoughts on Design *uses the simple, ordered pattern of the abacus, and, through controlled exposure, creates a sense of motion and depth.*

Art Kane's photograph for Look *magazine combines two nearly identical exposures of San Marco—one of them is inverted to create an intensely surrealistic image.*

The designer as photographer

In the world of visual communication, it is no longer possible to distinguish the art director from the photographer merely by the number of cameras he carries. The involvement of graphic designers in the photographic process has led to a situation in which some designers are taking their own pictures, and a few of them have moved on to become part-time or even full-time photographers. It is a rare art director who has never taken a photograph related to an assignment.

Most designers turn to the experienced professional when they want an illustration for reproduction, even though they may have had some photographic training and may do a certain amount of experimenting with the camera. Others create some of their own photographic solutions for design problems, but not all of them by any means. A third group is made up of those who divide their time between professional photography and graphic design. Some of this last group eventually make the move to full-time photography.

Among the photographers who have moved from highly successful careers as art directors to become topflight photographers are Art Kane, who began his career as an art director of *Seventeen* magazine; Carl Fischer, who began in advertising and promotion design; Otto Storch, who left *McCall's* to set up his own studio; and Henry Wolf, who continues to keep his hand in design despite a busy photographic career.

There is no question about this natural affinity between these two disciplines, and design students should be encouraged to become involved in photography. Taking pictures and drawing are the two best ways to sharpen perception, sensitivity, and intellectual curiosity. However, involvement in both design and photography is not without its

Carl Fischer began his career as an art director and designer, but he soon branched into photography and applied his sense of design and concept thinking to the production of a wide variety of images, like this deliberately contrived portrait of Richard Nixon for an Esquire *cover, art directed by George Lois.*

116

dangers. Thinking like a photographer can sometimes impair the designer's judgment when he is faced with the work of other photographers, and the innovative ideas that the professional photographer can contribute sometimes fall victim to the art director's own preconceived ideas.

Henry Wolf has blended highly successful careers as a designer of magazines like Esquire, Harper's Bazaar, and Show, *as an agency art director; and, more recently, as a photographer. His cover for Walter Herdeg's* Photographis *uses the camera to make a surrealistic image.*

Illustration

In the early stages of the modern design movement, drawn illustrations were an important element in the design of the printed page. Most early art directors were trained in courses dominated by Beaux-Arts attitudes toward draftsmanship and classic discipline. At a time when applied photography was in its infancy, there was a wealth of illustration talent willing to leave the fine arts for a more secure commercial career—artists like Eric Gill in London were ready to become involved in illustration and even typographic design.

The emphasis on elegance that characterized a large body of 1920s design brought a new concentration on style in illustration. This was evident in the modern posters turned out in Paris and London and in the work of illustrators like Carl Erickson, an American in Paris in the 1920s, who wore a bowler hat and signed his drawings ''Eric.'' His illustrations for *Vogue* and for American advertisers had an enduring character that approached the quality of the fine art of Bonnard and Matisse.

From the 1920s on, illustration was a major force in page design. By then, Norman Rockwell's *Saturday Evening Post* covers had become a national institution in America; N.C. Wyeth had set the style for narrative illustration; and Maxfield Parrish had introduced the soft look to calendar art. American magazines were crowded with illustrated fiction, and a golden era of illustration began that was to last for nearly three decades. Artist-illustrators like Austin Briggs, Robert Fawcett, and Al Parker were turning out impressive pages for magazines, while Eric, Edwin Georgi, and René Clark were making a similar contribution to advertising pages.

With the advent of the picture magazines

Carl Erickson, who signed his work ''Eric,'' was one of the many pioneers of modern illustration. This drawing for a Camel cigarette advertisement in 1930 looks surprisingly up-to-date over three decades later.

Life and *Look* in the 1930s, and with the rapid advance of photographic skills and techniques, the balance between photography and illustration began to shift in favor of the camera. By the 1950s, when magazine fiction began to decline under the pressure of competition from film and television, the golden era of magazine illustration had come to an end. Many illustrators shifted to nonfictional illustration, and they were joined by artists like Ben Shahn and Saul Steinberg.

By the 1960s, it was clear that a new direction was called for in illustration, and a new breed of artists began to challenge the camera with imaginative—

sometimes decorative—drawings that broke with the purely representational approach to drawn images. The Push Pin Studios and its assembled group of talented and often intellectual artist-designers, led by Milton Glaser and Seymour Chwast, were in the vanguard of this movement.

By the 1970s, illustration was moving in many different directions. A nostalgic revival of interest in Art Nouveau posters and a growing awareness of qualities that lurked in the excesses of Art Deco began to influence the shape of illustration. The "camp" images that had surfaced in the Pop Art movement of the 1960s often led to more crudeness than quality. Another

Illustrator Norman Rockwell used documentary subject matter in 1967, when he created this painting for Look.

1970s movement in the fine arts that has had a continuing influence on illustration is the neo-realist style, in which paintings are made to outshine the slickness of photography. And, regardless of the particular style of rendering, the subject matter of a large body of contemporary illustration owes a great deal to the Surrealist movement.

The natural affinity between the artist as illustrator and the artist as designer has created a linkage between these two disciplines that, in the end, may prove even stronger than the bond between photography and design. Most of the ideas that have guided the development of the modern movement were first revealed in the dynamic compositions of artists of much earlier times. We have learned a great deal about design from artists of the past, like Giotto, Uccello, Dürer, Hokusai, and a host of others. We have hardly begun to learn the lessons of twentieth century artists like Picasso, Matisse, Klee, and many others who have received wide recognition—and still others who are not yet established. Most of the seminal influences of the modern movement had their beginnings in painting, and many of the great innovators of the design movement were accomplished painters: Mondrian, Van Doesburg, El Lissitzky, Klee, and even Le Corbusier. The 1950s death notices of illustration were premature.

120

Milton Glaser is a designer and illustrator who works in many styles. This illustration from Show *magazine, art directed by Henry Wolf, reflects the sometimes grotesque aspect of contemporary subject matter.*

This illustration by Tetsu Vehara, a Japanese artist, for a management consultant service is indicative of the precise and graphic realism of much current illustration.

The designer as illustrator

One of the disturbing side effects of the modern art movement was the reassessment of draftsmanship in the education of artists and designers. Overlooking the sound knowledge of drawing that underlay the modern paintings of artists like Picasso, Matisse, and Klee, art schools began to abandon classic representational drawing in favor of "free expression" and abstraction. A generation of artists was trained under this system, and, though many of them learned to draw in spite of this neglect, the art world gradually realized that this rebellion against the classic disciplines had been overdone.

Though the actual skills of modern illustrators may not match those developed in the Beaux-Arts academies, the illustrators have made up for it in imagination and intellectual ideas. This shift of emphasis from technical performance to creative thinking has had a positive effect on illustration whenever the idea or *concept* dictated the style and character of the drawing.

It is not surprising that the group most responsible for this change of direction in illustration was closely identified with the design of the printed page. Typical of this new group were Milton Glaser and Seymour Chwast of the Push Pin Studios, which included both design and finished artwork in its services; Richard Hess, who combined meticulous illustration—often of a surreal character—with design; and Roy Carruthers, who came from art direction to develop his own unique distortion in representational drawing.

These designer-illustrators understood the need for simplicity and unified concept that is so essential to the design of the modern printed page. More often than not, they tied their illustrations to the overall design considerations of the

122

Roy Carruthers served as both an advertising and publication designer in London before turning to full-time illustration. The drawing above of vertigo, for Roerig Pharmaceutical, shows his somewhat rotund approach to anatomy contrasted with the vertical and parallel plumb lines.

page. They not only responded to the lessons in form and function inherited from de Stijl and the Bauhaus, but they were able to reach back to Art Nouveau, Art Deco, a touch of Dada, and a strong sprinkling of Surrealism to develop their personal styles. Their work also reveals occasional traces of the later experiments in optical and kinetic art.

Richard Hess moves between design and illustration. He has led the field in applying surrealism to the communication of contemporary ideas, as his cover art for the New York Times Magazine *at the left shows.*

Graphic illustration

Another form of artwork that is becoming increasingly important in the design of the printed page is graphic illustration. The growth of corporate design programs and the increasing demand for design solutions to informational, technological, and even scientific problems have created a new challenge to graphic design. Understanding the intricacies of statistical, tabular, and analytical content—and the communication of this material in a graphic, clearly articulated form—represents a new design opportunity.

This dramatic need in a changing society was first sensed by El Lissitzky and Theo Van Doesburg. It was later extended by Herbert Bayer, in his pioneering corporate design program for Container Corporation of America, and by Will Burtin, with his scientific images for the Upjohn Company and *Fortune* Magazine. More recently, design firms like Chermayeff and Geismar in New York, John Myles Runyan in California, and Pentagram in London have produced highly sophisticated design solutions to these intricate problems of communication.

Graphic illustration requires an unusual degree of general knowledge, a well-developed sense of logic in problem analysis, and a strong sense of visual organization. Because many of these problems deal with space and time-oriented concepts, the designer often turns to dimensional illusions, including perspective and isometric projections. He soon learns that problems that defy solution in conventional two-dimensional approaches will often respond to treatment in the isometric form. There is a remarkable number of ways that the same set of facts can be expressed, and finding the best solution may be difficult but rewarding work. If design and the computer are ever to join

124

The bar charts and pie charts of this annual report for Flying Tiger prepared by Robert Miles Runyan, a California design firm, are lifted out of their dull-as-dishwater category by the addition of imaginative design.

forces successfully, it will probably be first in the graphic presentation of information.

These two examples of informational graphics were created by Mervyn Kurlansky of London's Pentagram design studio to illustrate a handsome brochure for Nobrium.

Humor

Studies of editorial and advertising response have strongly supported humor as a way to capture and hold the interest of readers, yet the light touch is an approach too often neglected in contemporary page design. There are plentiful reasons for this neglect of humor. Nearly everyone takes himself too seriously, and this is particularly true of advertisers and publishers. Designers tend to overemphasize form and structure to the detriment of communication; and they are often overcome by the sheer difficulty of being amusing.

There is no other area of communication where a close coordination between copy and art is more essential. Without this happy union between word and image, the humor may end up with the hollow ring of a superimposed soundtrack of laughter or the absurdity of a good joke poorly told. There is always a danger that attempts at humor will leave the reader with a vague recollection of the joke and not the slightest idea of the message the page was meant to convey.

Throughout design history, from the Cassandre posters for Dubonnet to the Dr. Suess ideas for ''Quick Henry the Flit,'' humor has played an occasional but important role. One of the most consistent and effective uses of a light approach to advertising can be found in the campaign for Talon Zippers. We can all remember a few ideas that made us laugh, but humor has not been used as effectively or as often as it should be. Generally, the broadcast media have made more effective use of humor to convey messages that are often serious as well as persuasive.

The image-building promotion for Ohrbach's, a New York store, frequently uses humor effectively. The layout is by Robert Gage of Doyle Dane Bernbach.

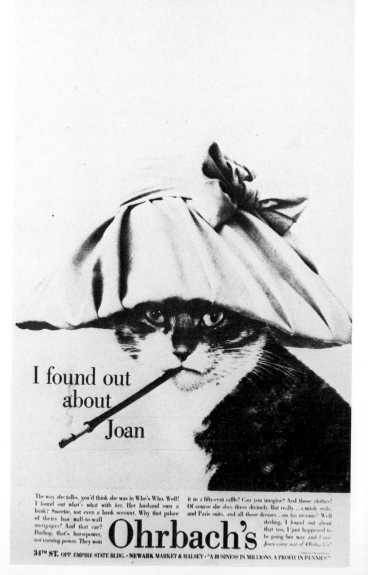

126

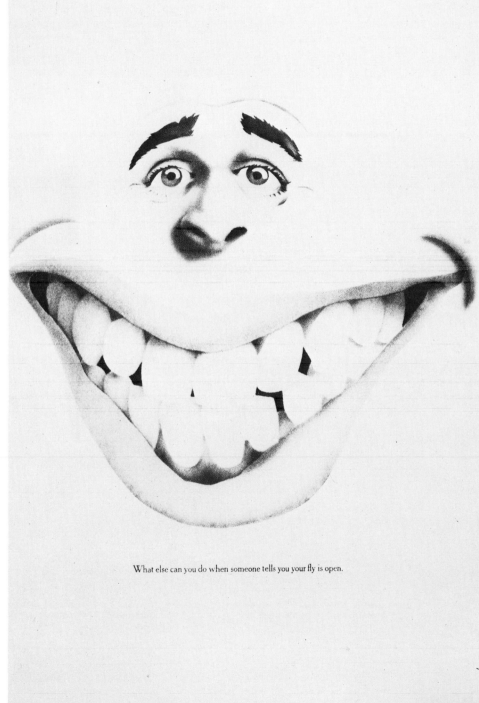

What else can you do when someone tells you your fly is open.

If you don't use the Talon Zephyr nylon zipper with Memory-Lock, a little device that keeps zippers up, your customers will have to keep on smiling. For all the wrong reasons.

Talon Zippers have been regular users of humor in their advertising. This layout was designed by Frank Fristachi with a drawing by Robert Grossman for the DKG agency.

Summary: The total effect

The design process requires continuous analysis and study of the elements that go together to make the complete layout. The background of visual research that goes into this analysis will vary widely, depending on the nature of the problem. Sometimes it is only necessary to think through the problem on the basis of the information on hand; sometimes it means discussion and the exchange of ideas with others; and sometimes it can involve firsthand study of the problem in the field. Thus, depending on the assignment, the designer may have to spend time in a wide range of locations, from the supermarket to social service centers, libraries, and available files.

Another aspect that the designer should consider before he picks up his felt marker is the continuity in which the layout appears. If the design represents a single effort divorced from other printed material, he will have a freedom of approach that does not exist in most design situations. If, however, the layout is part of a continuing campaign, a corporate design program, or an established format, its design will have to be harmonious with the overall effort.

One other factor of importance in the design process is the environment in which the page will be viewed. The designer must consider things like proximity to competing or distracting material, the method of delivery, and the light that will illuminate his layout under varying conditions.

A factor not previously mentioned—although it has an obvious bearing on the decisions a designer will make in the process of creating a layout—is the simple economics of the budget. The amount of money available to a designer will have a direct influence on choices between color and black and white between photography and illustration,

When Robert Gage designed this Doyle Dane Bernbach advertisement for the Jamaica Tourist Board, he created a grid and a strong logotype that would have a high recognition value throughout the advertising campaign.

and sometimes between line and halftone art. Economics can influence the choice of photographers or artists, and it can control our decisions about the methods of typesetting or printing. Of course, it does not follow that the more the designer has to spend the better the result. Many of the most successful and most enduring examples of graphic design have been turned out within very stringent budget limitations.

Throughout, this book has emphasized the totality of design and has stressed the all-encompassing nature of the creative solution. Although this may seem too obvious to merit such attention, a great many design failures are traceable to a weakness in this area. When a designer develops his idea by exploring the latest version of the newest typeface derived from the most obscure source, or (worse still) when he omits typography from his thinking completely until it becomes an afterthought, and *looks* like it; or when he starts with the assumption that it will all be taken care of in the finished proof—he is on the road to a design solution that will be mediocre at best.

A modest budget did not prevent Lester Beall from creating a highly effective design for the George Bijur agency.

response

Response: The significant exchange

The printed page has a special quality that influences its form, its content, and the reader's response to it. When a layout is printed, no matter how many copies are produced, no matter how widely it is distributed, and no matter how many people will be exposed to its message, the significant exchange takes place when each individual reader picks up his copy and turns his attention to the page. When a designer prepares a layout for the printed page, he is engaged in a highly personal line of communication. He is not on a stage, but he is in direct contact with the reader.

An understanding of his unique, one-to-one process of communication prepares the designer for a realistic approach to design. By changing our role from image-maker to image-viewer, we can avoid the self-indulgent solutions that often go unnoticed and unread. How we see (perception) and how we react (response) are two basic aspects of communication that can have a positive influence on design. To perceive an image is to participate in a creative process. As we look, we tend to isolate images from the mass of impressions we are exposed to and then add to them from our own knowledge, experience, and imagination. The sum total of a successful design includes the designer's cumulative knowledge and design experience, his creative projection of the idea, *and* the response of the viewer.

Many psychological studies and research programs have measured and analyzed the response of readers to the printed page. The most commonly used research technique is the survey of readership based on recall. In this approach, a selected group of viewers is subjected to a questionnaire aimed at determining the "depth of penetration"

133

René Magritte's painting, called The False Mirror, *is from the Museum of Modern Art, New York.*

of the page, based on the viewer's memory of his original encounter with the material. While this research technique has produced some useful information about the actual performance of a page and its comparative success against other competing pages, the findings have had little to offer that would aid a designer in facing new problems and determining future directions.

Another method of measuring response is by charting the actual optical response to the page through the use of an eye camera. This technique projects a fine beam of light onto the pupil of one of the subject's eyes and then traces its movement as the subject

is exposed to a page. The pattern is recorded on film and later superimposed on the image of the page. One weakness of this approach is its inability to reproduce an *actual* rather than a *clinical* viewing situation.

Some years ago, I had occasion to participate in a series of experiments with the eye camera and observe the results. My conclusion was that the technique offered no great value aside from confirming some rather obvious facts about visual response: the eye tends to approach the printed page in a random rather than an organized way; barring strong counteracting visual stimuli, the eye will first focus at an optical center

slightly to the right and slightly above the actual center; eye movement will tend to create a pattern going outward from this center point, and, except where it is involved in the actual reading process, the eye will not follow top-to-bottom nor left-to-right scanning patterns. Other weaknesses of this system include its inability to associate any of the movements with a mental response and the difficulty of averaging the collective reaction of several subjects to the same stimulus.

The more I have studied the attempts to apply scientific or psychological testing to the design process, the more I have become convinced that, most frequently,

A measure of response

One attempt at the scientific measurement of response was the use of the eye camera which was designed to trace the pattern of optical movement by following a highlight reflected in the pupil of the subject's eye as it scanned the page. The image at the right represents a typical pattern of that movement on a spread from Look *magazine when viewed by a reader under controlled conditions.*

the reliance on any of these approaches leads to repetitious, imitative, or mediocre results. The search for formulas and proven devices also tends to divert the designer's concentration from the specific requirements of the project. For that reason, this section will concentrate on the broad psychological aspects of perception and the illusions that influence visual response and comprehension.

We accept the way we see things as a fixed—not a changing—condition. Actually, our perception is being constantly modified by genetic and environmental influence. Man's perception of color probably came late in the evolutionary process. The perspective illusion that is generally accepted as reality today was not a part of our visual awareness until the fifteenth century, and abstract images are still being absorbed as part of our visual language in the twentieth century. As our vision moves outward toward space and inward toward the atom, our neatly packaged concept of measurable space and a round world that revolves around a reliable sun is threatened by still more changes in our ideas about perception.

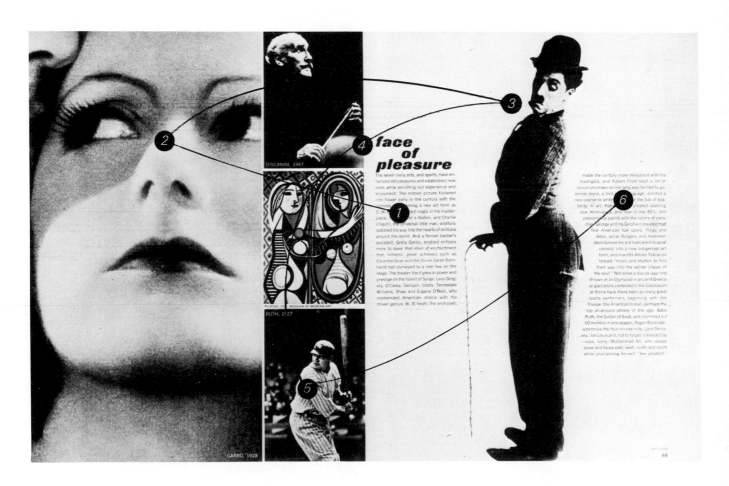

Perception: Gestalt psychology

As noted earlier, great changes began to take place in art and design around 1910. It is not surprising to discover that the development of a design-related psychology began at about this time. In 1912, Max Wertheimer published a paper on perception that is generally credited as the beginning of Gestalt psychology.

The German word ''Gestalt'' does not translate easily into English. ''Form'' and ''shape'' are the usual synonyms, but the word generally implies a configuration of many elements to form a unified whole as in the creative design of a layout. Wertheimer's principles of perceptual organization demonstrate how the eye tends to group units within the field of vision into wholes. This approach established vision as a creative experience—not simply an act of seeing.

It is our ability to gather and group visual patterns, to view units collectively, that permits us to accept the printed page as a total unit. It is this phenomenon of perception that creates the need for design solutions that bring together all the elements in a total concept. The Gestalt principles not only explain how we combine sensory data to form objects, but they also hint at why we accept the illusion of tone created by halftone dots, the simplified form of cartoon art, the meaning of symbols, and the intrigue of abstraction. The Gestalt studies of vision also suggest why we are sometimes able to see images that don't exist—like the man in the moon—images in a moving cloud pattern, or images in the Rorschach blot familiar in psychological testing.

In exploring the visual effects of an object under varying intensities of light, the Gestalt scientists discovered and explained the phenomenon of value

The Gestalt psychologists explain perception as the organization of sensory data into whole units or objects. Though there is a strong tendency to identify information organized in rows, elements can also be grouped by proximity or similarity. The implied perspective of the converging rows at the left and the shape formed within that unit also suggest our ability to organize and identify images.

contrast. They established that an object of constant value will appear darker on a light background and lighter on a dark background. And they also explained why we sometimes sense movement in a fixed object, like the illusion of the moon moving through clouds, when in reality the clouds are in motion. In general, these scientists reinforced the view of relative perception, which explains the different impression received from the same object when its environment changes—a red disk may mean different things in different settings.

The experiments of the Gestalt psychologists also confirmed that words and word groupings were more important to typographic legibility than were the form and shape of individual letters. In their studies of children and the learning process, they determined that the perception of three-dimensional space came earlier and more readily to a child than the understanding of the two-dimensional plane and the three-dimensional illusion. This explains why children are slow to accept perspective and why they rarely use it in their own drawings.

Gestalt continues to be the principal source of scientific information on perception and response. The ability of the eye and mind to assemble and arrange elements and understand their meaning is at the root of the design process and provides a key to effective page layout.

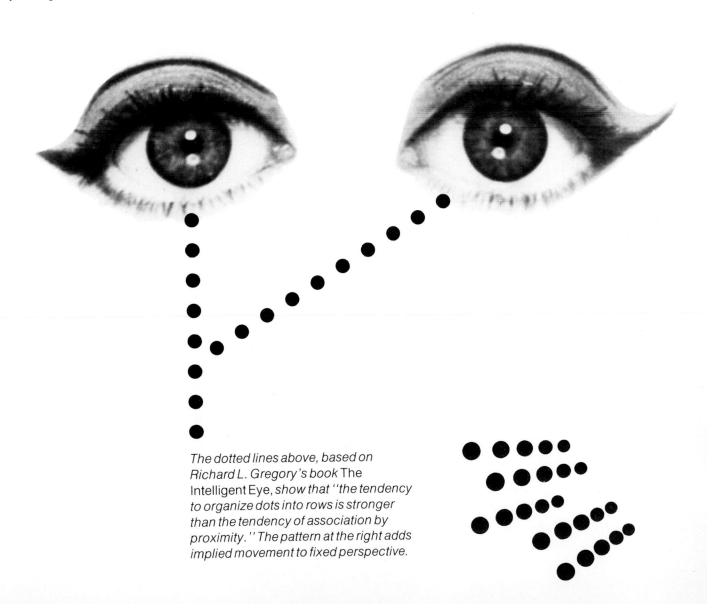

The dotted lines above, based on Richard L. Gregory's book The Intelligent Eye, *show that "the tendency to organize dots into rows is stronger than the tendency of association by proximity." The pattern at the right adds implied movement to fixed perspective.*

Illusion: The changing view

When we compare hearing and seeing, we tend to think of hearing as a more abstract sensation than sight. It is true, of course, that when we hear a sound unaided by the other senses, it is difficult—if not impossible—to determine its nature, location, and distance from us. On the other hand, with a reasonable accumulation of visual experience, we can not only recognize an object, but we can usually pinpoint its location and make a reasonable estimate of its

distance from us. "Seeing is believing," we say, and we accept vision as the most absolute of all of our senses—but how absolute is it?

The common tendency to think of the eye as the lens of a camera that produces a picture in the brain is inaccurate and misleading. As the Gestalt psychologists discovered, perception is not a photographic process. It is, instead, a complex response that gathers and groups the visual information it encounters into mosaics that shape our mental pictures of the objects we see. Vision is a conditioned response, and, while there is certain evidence that some visual phenomena (like depth

perception) may be innate, most visual awareness comes through knowledge and experience served by other senses, as well as by sight.

When we respond to certain retinal stimuli by grouping them to provide an *inaccurate* image, the result is an ambiguous illusion. The best-known ambiguous illusion is the reversal between negative and positive forms. This is most commonly illustrated by two facing black profiles in silhouette that create the shape of a symmetrical white vase made up of the space between the silhouettes. This figure-and-ground illusion has a relationship to some design problems, such as using type as a plastic

138

Another enigma of the world of illusion is the Necker Cube, which seems to reverse its depth as it is viewed (above). One moment it is seen from above, and the next from below.

The world of illusion is filled with many unexplained visual phenomena. One of the most common and most puzzling of these is the Muller-Lyer arrow illusion, in which lines of equal length seem to become longer or shorter when the arrow heads are reversed (below).

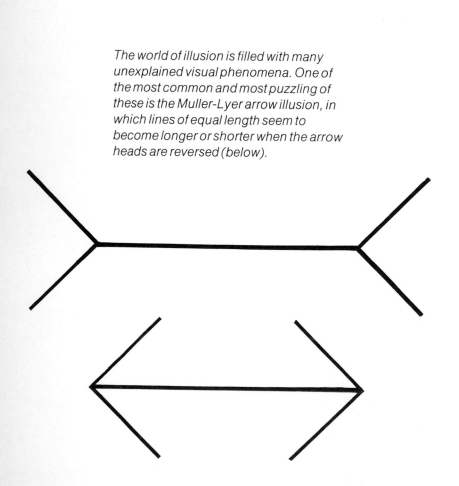

element. Here the white space within the letters is often as important an aspect of form as the positive black shapes that make up the letters.

Another common illusion that relates to design is dimensional ambiguity, where a simple outline of a cube appears to reverse its position from above our line of sight to below it. This is known as the Necker cube. While it is usually shown with parallel receding lines (isometric) rather than converging lines receding to a vanishing point (perspective), the reversal holds true—although with a reduced intensity—even when a three-dimensional wire construction is used to demonstrate the cube. Joseph Albers, who taught at the Bauhaus and has received worldwide recognition for his work, *Interaction of Color*, also explored this dimensional paradox in a series of black and white engravings called *Structural Constellations*.

Anyone who has shown the slightest curiosity about the visual experience is well aware of the importance of relative forces in vision. A color can seem to change under the influence of another adjacent color; a straight line may seem to bend under the influence of converging lines that cross it; an object may seem smaller in proximity to a large object. One of the most dramatic of these

Josef Albers, the noted Bauhaus artist and teacher, spent a lifetime exploring color and illusion. This print, from his series called Despite Straight Lines, *represents a highly sophisticated view of the illusion of the Necker cube.*

visual comparisons is contained in the Muller-Lyer arrow illusion, where the shaft of an arrow seems to become appreciably longer when the lines that mark the point are directed outward and away from the line, instead of inward as on most arrows. While many theories have been advanced to explain this illusion, a definitive answer has not yet been discovered.

The illusion of motion—not the suggestion of movement as practiced in Futurist painting, but the actual stimulation of an apparent surface movement in the eye and mind—is one of the most baffling of the optical illusions. This effect has been a principal force in

Op art, where the painted surface seems to shift, shimmer, or undulate. Although we are fully aware that these undulations are an illusion and no real movement is involved, it is impossible to avoid their effect, short of looking away. Even then, the illusion may pursue us in a series of afterimages. As in some other areas of vision, no exact explanation for this phenomenon has yet been determined. In general, though, it is related to a fatigue factor brought about by the complexity of the design and has been compared to an overloaded circuit in a computer.

In one way or another, all of these illusions confirm that the two-

dimensional page can only create an *impression* of a three-dimensional world. They also demonstrate that it is possible to create some strange and misleading side effects in visual communication. Illusions reinforce the excitement of the visual experience, even though we know so little about this complex and critical aspect of the exchange of ideas—which is barely touched on here. Designers who want to study perception in more depth will find valuable information about vision in *Eye and Brain* by R.L. Gregory and about art and perception in *Art and Illusion* by E.H. Gombrich and *Art and Visual Perception* by Rudolf Arnheim.

140

Our depth perception is influenced by the source of light and the direction of shadows. In the NASA photograph at the right, when the light comes from above we easily distinguish the craters on the moon (above), but, when we turn the picture around and the light comes from below, the craters look like hills.

One of the most perplexing of all the
illusions is the implied motion of certain
static images. It is impossible to keep our
eyes at rest when the picture above is in
our field of vision. The sense of
movement is compounded by our effort
to organize the complex sensory data.

In this optical pattern, the sense of
movement becomes even more
inescapable. When confronted with the
wavy lines, our eye movement is
reinforced by a combination of
afterimages and eye fatigue until the
undulating motion seems real.

The visual paradox

An awareness of illusion and perceptual ambiguity reminds us that things are indeed *not* what they seem. If perspective is not a totally reliable representation of reality, it can be turned around and used to serve the designer's or the artist's purpose. If the designer or artist can represent objects on the two-dimensional surface that could not exist in the three-dimensional world, he opens up new areas of creative expression. Realistic painting has often undertaken to confuse the eye by altering or disrupting the three-dimensional illusion, modifying reality, or seeking out disturbing ambiguities of vision.

With the advent of Surrealism (see page 24) as an art form, new explorations were made with respect to the visual paradox. Salvador Dali changed the molecular structure of material when he composed pictures of drooping watch faces in his *Persistence of Memory.* René Magritte floated imponderable objects in space and placed unbelievable views in his windows. With all of their jolting approach to reality, the painted surfaces of these artists have a classic, carefully drawn finish. While they may have changed the nature of material and violated the laws of gravity, they never broke the rules of perspective rendering.

It remained for another twentieth century artist to bring the ultimate unreality to realism by using perspective to serve his own ends. M.C. Escher, a master etcher and printmaker, used illusion and ambiguity more directly than any other contemporary artist. He created dimensional paradoxes that showed multiple viewpoints within a picture, buildings that changed perspective between floors, and stairways that went ever upward, even though joined in a closed rectangle. His work was not Freudian, but it created its own surreal

142

This 1974 illustration by Richard Hess from a brochure for the Xerox Corporation creates a visual paradox that permits two figures to ascend and descend the same flight of steps in the same direction.

effect by taking advantage of perceptual ambiguities. His drawings—which look logical and real until we take a second look and realize they could never exist— have inspired graphic ideas with surrealistic overtones.

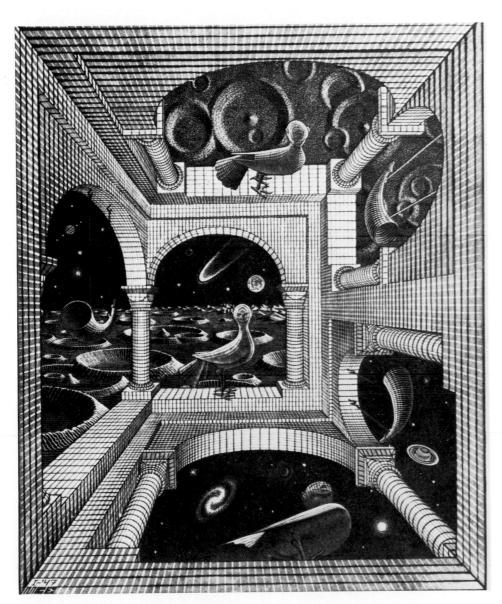

M.C. Escher's 1947 woodcut called Another World *builds a paradox by confusing the multiple planes of wall, floor, and ceiling. He makes us look upward, downward, and sideways at the same time in this impossible vision.*

Conclusion: The measure of a design

Throughout his career, a designer will be expected to make decisions concerning the quality of graphic design. This will begin with the personal, critical decisions that guide him in selecting one of many preliminary sketches to develop into presentation form. The process continues in the judgment of the work of his peers—in both the casual appraisal of their work and the more formal judgments called for when he must select their designs for exhibitions and awards.

The work reproduced in this volume has been created by many designers, and represents a wide range of communication objectives approached under varied conditions over an extensive period of time. Some of the illustrations represent designs that have been widely honored and recognized. A few, for one reason or another, have eluded the spotlight. But they all share some basic and common characteristics. They are all based on the simple presentation of a single commanding idea. They are all tuned to the interest and response of a broad or selective group of viewers. They all reflect the influences of contemporary style without becoming fashionable or self-indulgent. And they carry the stamp of the designer's personal style, based on a blend of his objective and subjective involvement.

There is one other measure of layout quality, which many of the designs on these pages demonstrate—a certain timelessness. Though many of the examples selected are ten, twenty, thirty, or even fifty years old, nearly all of them would be considered effective designs if they were published this year. In my judgment, the word ''dated'' could not be applied to any of them. It is this enduring quality that represents the final measure of a great graphic design.

In reviewing the process of layout, it may

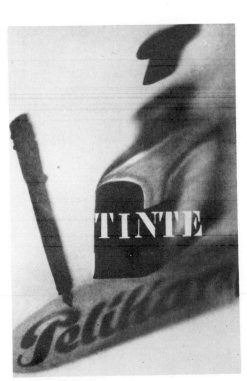

El Lissitzky, 1924

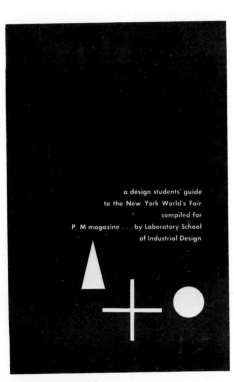

Paul Rand, 1939

Herbert Matter, 1935

All three of the above layouts, also shown on pages 29, 72, and 66, were designed over 35 years ago, and the Lissitzky advertisement dates back more than 50 years, but all of them retain a freshness and enduring quality characteristic of all truly creative modern designs.

even be appropriate to turn this book around and reexamine the material, beginning with response and ending with style. In many ways, this is a more logical procedure. Nothing is more essential to visual communication, and hence to graphic design, than perception and response.

Vision is not a mechanical process in which the eye, like the lens of a camera, transmits pictures to the brain in fully developed form. Instead it is a complex, computerlike procedure in which our eye gathers bits and pieces of sensory data and transmits them to the brain, where they are sorted out and restructured into objects and images. These images may

be effective or boring; they may be remembered or forgotten; or they may be misread or transposed into one or another of the ambiguities we call illusions. Whatever occurs at this point will be critical to the measurement of the graphic quality of our design.

It would be a major error to assume that gaining the attention of the reader represents the end of the exercise. Unless the visual response induces an intellectual or emotional reaction, no true communication has taken place. This is true whether the objective is information or persuasion, and the degree of reaction to the content of the layout will be intensified or reduced by the form and,

finally, by the style of its presentation.

Some seventy crowded years have passed since Frank Lloyd Wright brought his early career to a climax with the Robie house and Pablo Picasso upset the course of art with his first Cubist painting. In those years, a great deal has happened. At first it seemed that everything that made up the modern design movement had come together and that the revolution was complete by the end of the 1920s at the Bauhaus. It is certainly true that a large body of contemporary graphic design is directly related to (or at least guided by) the traditions and design principles established by Paul Klee, Josef Albers,

146

Will Burtin was one of the first designers to effectively move from the technological attitudes of the Bauhaus to the scientific challenge. This cover for a medical magazine published by the Upjohn Company is an early example of his graphic approach to scientific subjects.

Moholy-Nagy, and Herbert Bayer.

But in the years that followed, there was a growing awareness that somewhere in the distillation process that design underwent at the Bauhaus, something may have been lost of the pioneering ideas held by designers like El Lissitzky and Theo Van Doesburg, and painters like Arp, Mondrian, Duchamp, and Leger. Some designers also felt that the rejection of ornament and decoration might have been carried too far.

By the late 1960s, a growing number of graphic designers were exploring the bypassed outcroppings of Art Nouveau, and some of their layouts were showing traces of Art Deco slickness. In the years that followed, the influence of nineteenth century posters and even Pre-Raphaelite romantic paintings began to appear. Some of this exploration was a legitimate search for a broader and more fertile base for new ideas; some of it was a reaction to the ultimate simplicity of the International style; but most of the layouts produced by this surge of nostalgia were merely fashionable pastiches that already look out-of-date. The layouts that did succeed were those designed with the simple divisions of space advanced by the masters of modern design—and these layouts were not only the most effective, but will probably be the most enduring as well.

The subject matter of the pictures may seem dated in this Time *magazine advertisement designed by Lester Beall, but his original concept and use of asymmetrical form is as appropriate to the advertising objective today as it was in 1938.*

Acknowledgments

It is impossible to fully acknowledge or accurately credit all of the bits and pieces of valuable information and printed material that have been gathered together to make up this book. In one way or another, the entire design profession and everyone working in this somewhat loosely defined area has contributed to the course of design history and hence to this volume.

I would like to acknowledge the assistance of Don Holden, the Editorial Director of Watson-Guptill Publications, who suggested the original approach to this book, and Ellen Zeifer, whose editing reinforced its clarity. I am grateful to my wife Regina, who played so important a role in keeping my ideas in line, and my daughter Susan, for the early editing of my text.

The dominant single source of information and material for this book has been my own extensive archive of documents, proofs, and photographic negatives accumulated over more than forty years as a practicing designer and observer of the design profession. Wherever possible, I have gone back to original sources and sought all appropriate and available permissions from the designers whose work is reproduced on these pages.

Perhaps the most important single archive for information on the course of twentieth century design is The Museum of Modern Art in New York. In 1934, its now-famous Design Collection was established under the guidance of Alfred Barr, its founding director. His discerning and farsighted view of the art and design movements of this century have provided an unmatched perspective with which to understand modern design. I am also particularly grateful to Mildred Constantine, who for many years served as Associate Curator of the Design Collection. Her documentation of the history of graphic design and printed images and her continuing liaison with the international design profession provided much of the background for my research.

In addition to the Museum of Modern Art, many other institutions contributed to the content of this book. The list includes the Library of Congress and the National Collection of Fine Arts in Washington; the British Museum and the Victoria and Albert Museum in London; the Bibliothèque Nationale in Paris; the Stedelijk Museum in Amsterdam; and the Württembergischer Kunstverein in Stuttgart. I am also particularly grateful for use of the facilities and the assistance of the staff of the London College of Printing design library and learning resources center.

The *Art Directors Annuals,* published by the Art Directors Club of New York since 1921, have provided me with a great deal of material on an important segment of the communication design field. Without these documents and without the continuous service to the design profession of organizations like the Art Directors Club and the American Institute of Graphic Arts, an undertaking like this would have been impossible.

Other publications that have served as valuable sources of information are: *Graphis Annual* and *Photographis,* published in Switzerland; The *Penrose Annual* and the *D & AD Annuals,* published in London; and the *Illustrators Annual,* published in New York. Periodical publications are also important sources of information on layout and page design. These include *Graphis,* edited by Walter Herdeg in Zurich, Switzerland; *Communication Arts,* edited by Richard Coyne in Palo Alto, California; and *Print,* edited by Martin Fox in New York. Other publications have also made substantial contributions to design, though they enjoyed relatively short lifespans. They include *Advertising Arts* (1929–1931); *PM* magazine, later named *AD,* published by Dr. Robert Leslie in the early 1940s; *Portfolio* magazine (1950–1951) and *Arts et Métiers Graphiques,* published in Paris before World War II; and *Gebrauchsgraphik* in Germany.

Photographic credits: Most photographers are credited in the captions accompanying the illustrations. The following list covers some of the photographs not previously credited: page 31, Richard Avedon; page 33, Philip Harrington; page 57, Paul Fusco; page 67, Irving Penn; page 73, Philip Harrington; page 82, Pete Turner; page 83, Will McBride; page 94, Bert Stern; page 101, Carl Fischer; and page 128, Elliott Erwitt.

Bibliography

Design: Arnheim, Rudolf. *Art and Visual Perception.* Berkeley: University of California Press, 1974; London: Faber and Faber, 1974.

Art Directors Club. *Annual of Advertising and Editorial Art.* New York: Watson-Guptill Publications (1921–).

Craig, James. *Production for the Graphic Designer.* New York: Watson-Guptill Publications, 1974.

Gombrich, E. H. *Art and Illusion.* New York: Bollingen Series, 1961; London: Pantheon Books, 1960.

Gregory, R. L. *Eye and Brain.* New York: World University Library, 1973.

—————. *The Intelligent Eye.* New York: McGraw-Hill, 1970; London: George Weidenfeld & Nicolson.

Herdeg, Walter. *Graphis Annual.* New York: Hastings House; Zurich: Graphis Press (1952–).

Hofmann, Armin. *Graphic Design Manual.* New York: Van Nostrand Reinhold, 1965.

Hurlburt, Allen. *Publication Design.* New York: Van Nostrand Reinhold, 1976.

Kepes, Gyorgy. *Language of Vision.* Chicago: Paul Theobald, 1945.

—————. *The New Landscape.* Chicago: Paul Theobald, 1956.

Le Corbusier. *The Modulor.* Cambridge: Harvard University Press, 1954.

Müller-Brockmann, Josef. *The Graphic Artist and His Desigh Problems.* New York: Hastings House, 1961.

Rand, Paul. *Thoughts on Design.* New York: Van Nostrand Reinhold, 1971.

Tolmer, A. *Mise en Page: The Theory and Practice of Layout.* London: The Studio Ltd., 1930.

Design History: Baljev, Joost. *Theodore van Doesburg.* New York: Macmillan, 1975; London: Studio Vista, 1975.

Banham, Reyner. *Theory and Design in the First Machine Age.* 2nd ed. New York: Praeger, 1967; London: The Architectural Press, 1960.

Barr, Alfred H., Jr. *Masters of Modern Art.* New York: The Museum of Modern Art, 1959.

Bayer, Herbert, ed. *Bauhaus 1919–1928.* New York: The Museum of Modern Art, 1972.

Bojko, Szymon. *New Graphic Design in Revolutionary Russia.* New York: Praeger, 1972.

Constantine, Mildred, and Fern, Alan. *Revolutionary Soviet Film Posters.* Baltimore: John Hopkins University Press, 1974.

———. *Word and Image.* New York: The Museum of Modern Art, 1968.

Cooper, Douglas. *The Cubist Epoch.* London: Phaidon, 1970.

Drexler, Arthur. *Twentieth Century Design.* New York: The Museum of Modern Art, 1959.

Gray, Camilla. *The Russian Experiment in Art 1863–1922.* New York: Scribner, 1973; London: Thames and Hudson, 1973.

Klee, Paul. *The Inward Vision.* New York: Harry N. Abrams, 1958.

Moholy-Nagy, Sibyl. *Experiment in Totality.* Cambridge: MIT Press, 1969.

Kuppers-Lissitzky. *El Lissitzky.* London: Thames and Hudson, 1968; New York: New York Graphic Society, 1968.

Rubin, William S. *Dada, Surrealism, and Their Heritage.* New York: The Museum of Modern Art, 1968.

Selz, Peter, and Constantine, Mildred. *Art Nouveau.* New York: The Museum of Modern Art, 1976.

Scully, Vincent. *Frank Lloyd Wright.* New York: George Braziller, 1960.

Taylor, Joshua C. *Futurism.* New York: The Museum of Modern Art, 1961.

Van Doesburg, Theodore. *Principles of Neo-Plastic Art.* London: Lund Humphries, 1969.

Wingler, Hans M. *Bauhaus.* Cambridge: MIT Press, 1969.

Illustration Fawcett, Robert. *On the Art of Drawing.* New York: Watson-Guptill, 1958.

Herdeg, Walter. *Graphis Diagrams.* New York: Hastings House, 1974; Zurich: The Graphis Press, 1974.

The Push Pin Style. Palo Alto, CA.: Communication Arts Books, 1970.

The Society of Illustrators. *The Illustrators Annual.* New York: Hastings House (1959–).

Photography Herdeg, Walter, ed. *Photographis Annual.* New York: Hastings House; Zurich: Graphis Press (1951–).

Newhall, Beaurnont. *The History of Photography.* New York: The Museum of Modern Art, 1964.

Pollack, Peter. *The Picture History of Photography.* New York: Harry N. Abrams, 1970.

Rothstein, Arthur. *Photojournalism.* New York: Amphoto, 1973.

Szarkowski, John. *The Photographer's Eye.* New York: The Museum of Modern Art, 1966.

Typography Burns, Aaron. *Typography.* New York: Van Nostrand Reinhold, 1961.

Craig, James. *Designing with Type.* New York: Watson-Guptill, 1971.

Hlavsa, Oldruich. *A Book of Type and Design.* New York: Tudor, 1960.

Rosen, Ben. *Type and Typography.* New York: Van Nostrand Reinhold, 1970.

Ruegg, Ruedi and Frohlich, Godi. *Basic Typography: Handbook of Technique and Design.* New York: Hastings House, 1972.

Spencer, Herbert. *Pioneers of Modern Typography.* New York: Hastings House, 1970; London: Lund Humphries, 1970.

Swann, Cal. *Techniques of Typography.* New York: Watson-Guptill, 1969; London: Lund Humphries, 1969.

Index

W

X

Y

Z

Edited by Ellen Zeifer
Designed by Allen Hurlburt
Composed in 10 point Vega Light